Heartways

The Exploits of Genny O

Heartways
The Exploits of Genny O

Edited by Rita McBride
and Erin Cosgrove

ArsenalAdvance
Whitney Museum of American Art
Printed Matter, Inc.

HEARTWAYS: THE EXPLOITS OF GENNY O
Stories copyright © 2004 by the authors

Cover and interior design by David Gray
Front and back cover images by Kathy Slade

Printed and bound in Canada

National Library of Canada Cataloguing in Publication
 Heartways : the exploits of Genny O / edited by Rita McBride ; with Erin Cosgrove.
Copublished by: Whitney Museum of American Art, Printed Matter Inc.
ISBN 1-55152-160-1
 I. McBride, Rita, 1960- II. Cosgrove, Erin III. Whitney Museum of American Art
IV. Printed Matter, Inc. V. Title: The exploits of Genny O.
PS8600.H43 2004 C813'.6 C2004-900677-0

This project is a copublication between ArsenalAdvance, the Whitney Museum of American Art, and Printed Matter, Inc.

ARSENALADVANCE
an imprint of ARSENAL PULP PRESS
103 - 1014 Homer Street, Vancouver, BC, Canada V6B 2W9
arsenalpulp.com
Arsenal Pulp Press gratefully acknowledges the support of the Canada Council for the Arts and the British Columbia Arts Council for its publishing program, and the Government of Canada through the Book Publishing Industry Development Program for its publishing activities.

WHITNEY MUSEUM OF AMERICAN ART
945 Madison Avenue, New York, NY 10021, USA
whitney.org
The Whitney Museum of American Art is the leading institution of twentieth- and twenty-first-century American art and culture. An essential forum for American artists since its founding in 1930, the Whitney's goal is to champion freedom of artistic expression and to foster the development of art in America.

PRINTED MATTER, INC.
535 West 22nd Street, New York, NY 10011, USA
printedmatter.org
Printed Matter, Inc. is an independent 501(c)(3) non-profit organization founded in 1976 by artists and art workers with the mission to foster the appreciation, dissemination, and understanding of artists' books and other artists' publications.

CONTENTS

A CHAPTER

Genny O lived on the seventeenth floor of a brand new Brooklyn highrise. She sat on a chair and stared out the window. It was a raging, clear March day and if she stood she could see New Jersey. She was sitting in her chair right next to the living room window in order to get a better downward angle on the steady stream of cars rounding the curve at the Battery Tunnel. She liked those cars and the people who drove them. They were headed north too late for work, at least too late for any regular work. If those people had jobs they were off-hour jobs she could identify with: waitresses, dogwalkers, elevator operators, professional shoppers, or people with flexi-schedules who worked at home and could report to the office whenever they liked. Better yet, she imagined they were people with no jobs at all, like her, waking up late and cruising into the city with nothing better to do. She counted herself as one of them.

Every day she would wake around nine and shower, have some coffee and maybe breakfast, and by then it would be after ten. She would be heading downstairs

to her car about then (if she had one) to go cruising into the city to hang out and see what she could pick up for free without breaking any laws. Instead she would sit backwards in her wooden chair, her legs spread by the chair's back and her chin resting on her forearms, and watch the cars go by in silent slow motion. She didn't like cars up close; she couldn't stand the disappointment of them. They were much nicer when seen from a distance, with no rust or dents or loose manifolds or whining fan belts, perfect. Total noiselessness and grace. From a distance the only thing she sensed was their slow and beautiful progress toward the Brooklyn Bridge.

Their beauty was their purpose: to get somewhere (slowly). She would sit there until the cars thinned out around noon, then she wouldn't watch them for the rest of the day. The traffic was too sporadic in the early afternoon before becoming an excruciating rush-hour crawl in the opposite direction home. She didn't like to watch the cars inch home, curling around the bend at Atlantic Avenue. It was too obvious. She didn't like seeing a particular car way back in the slow-moving pack, maybe as far back as Kane Street, lurching and stopping in the rush hour manner until it inevitably disappeared. She would see it and know immediately that, from that point on, it was only nearing the moment when it would be gone. She couldn't change it so she didn't watch.

Two smaller windows in her apartment faced west, one in the kitchen and one in the bathroom. There were many coin-sized, clear-plastic suction cups stuck to the kitchen window as well as the refrigerator and the counter.

Various prisms, trinkets, and plastic toys hung from them with string or hung directly from their metal hooks. When she first saw the suction cups at the store she thought: how stupid. Now she had several dozen of them.

After the morning cars waned and she was no longer one of them, she would eat lunch. Then she would read for a while and would eventually wander down to the ground, to see what it was like. Every day she would fiddle around in her apartment trying to ignore the appeal of the ground, trying to convince herself that it was the same as yesterday, but sooner or later she would end up in the elevator. She would step into the lobby, out the double glass front doors, and that's when it would hit her: radios blaring, people talking, shouting, cars grinding by on the BQE, the wind blowing grocery bags and newspapers across the building's grounds, the rattling trees. She would walk across the parking lot to the grass and hear every pebble and shard of glass beneath her feet.

Every day the ground seemed newly strange to her. She never ceased to be impressed by the changes that occurred from one day to the next. She noticed small things: a newspaper that had been wrapped around a tree by the wind and pinned there for days until it seemed permanent, would suddenly be gone. Some days it would be the springiness of the grass, or the wind's temperature and direction, or the color of New York harbor that struck her as new, different. Sometimes it was the tenor of people's voices, angry or playful or ordinary, conversations about baseball or the fate of someone's auto. It wasn't that she was really looking for these things; she just had an uncontrollable urge to visit the ground everyday and see if it

was still there, intact, different. If she ever went down and found everything exactly the same as the day before, that would be the end of her. She would know then that she had seen enough, seen it all and then some. She might as well jump out the window and splatter on the ground. Now that would be different.

That would be the end.

Of course it happened. A day came along that was exactly the same as the one before. It startled her and greatly saddened her. It had started out fine, this day: she woke and made a particularly pleasant pot of coffee. She watched the cars until twelve-thirty, ate a sandwich for lunch with the last cup of coffee on ice, and read the paper. (She liked to read the paper a day late. During her daily outings she would inevitably stop by the corner deli, which always had papers leftover from the day before, so she would get one for free. What difference did it make? As long as she never missed a paper she would know as much as everyone else did, just one day later. What was a day, more or less?) Around two-thirty gravity called her and she descended to the ground.

She couldn't believe that it was possible, that it would ever happen. It was strange at first, confusing in that it was so familiar. That was strange. She just walked outside and it seemed the same. She carefully took in the mid-afternoon noises and smells, watched the light change as it fell on the ground in front of her, felt the rubble below her feet. She walked to the pedestrian overpass, zigzagged up the stairs, crossed it, zigzagged down, and then walked all the way to the harbor's edge. She watched the meek waves get

slapped around on the rocks, then crossed the broken stone and concrete landfill to the north until she could see the southern tip of Manhattan through the haze. In the foreground: the vertical members of the new convention center partially blocked and punctuated her view. To the left: freshly planted trees, new in town. To the right: the old convention center, a modern relic from the 1960s, being dismantled by hand. First she thought: there's something I could do; then the irony of the scene occurred to her. Here was a type of architecture whose prefabricated components, designed to minimize on-site labor costs, had backfired when the time came for the building to be demolished. The labor eliminated thirty years ago had returned in a different form. Bolted and hot-riveted into place, the modern building was immune to the good old-fashioned kind of demolition that could bring down centuries of masonry with one detonator's plunge. The funny thing was, people who made buildings out of stone and brick worked as if they would stand forever, and people who made steel buildings talked about designed obsolescence. Now, the opposite of both was true. She wondered if the modern building dismantlers had a union.

She walked back along the harbor's edge, back across the overpass, back to her building. Instead of returning to her apartment she stood inside the lobby and just stared out at the ground around her. From behind glass, the ground had a strange, murky look at ground level. She had never noticed this before. She was only aware of the landscape when she was in it, walking across the materials that made it up and distinguished it from the air. If she had tried, she could have found or construed something different about the day

that satisfied her. That was easy enough. But that didn't count. Those would be conscious things, calculated things, mere reactions to the eerie familiarity that enveloped her. It had to feel different. It didn't.

Instinctively she had gone for a protracted walk and looked at the bridges and the harbor and the city from different angles, but not in an effort to solve her dilemma. It was her way of realizing her situation and suspending, lengthening, the day. It was a form of eulogy, a slow motion tip of the cap, one long, last walk home.

She returned to the elevator, to her sofa, and watched the sky become night. She took solace in the fact that the people and mechanisms of the earth had nothing to do with the coming of night. She often slouched down on her sofa in the evenings, staring out at just such an angle that not a single glimmer of artificial light could be seen, not a single building or smokestack or airplane, and yet night would always come. On this day the sky contained by the pure square frame of her window was a field of remarkably even and heavy gray clouds moving steadily northeast.

After dinner she didn't go to bed or read or do the crossword puzzle or watch TV. Instead, she continued to sit on the sofa and stare out the window into the lightless night. But she wasn't staring out the window as much as she was staring at it: looking at the reflections of her living room in the surface of the glass. And she wasn't interested in the contents of her living room as much as she was the point at which the light in the room bounced back to her from the windowpane. On the other side of the pane's thickness, a healthy wind rattled the building and flecked it with rain. The glass

looked alternately transparent and opaque, thin and thick, clear and black. On bright blue days the window looked like a solid chunk of blank advertising, perfectly clean clear air. The window looked like a cigarette ad with all the cigarettes, people, trees, dogs, glass table-tops, wicker chairs, wine glasses, and linen jackets removed. Pure blue sky.

Tonight the sky and glass looked like water.

Around two-thirty in the morning the clouds cleared. They'd been going at their pace for several hours until they dispersed like the edges of a cattle herd. The stragglers slid across her view. The stars "came out," as they say, but she knew better. She knew they'd been there all along. The stars completely filled her window frame. She played a game with them on the pane. The game was to draw a line from one star to another, then to another, then intersect the first line with the third in the process of moving towards yet a fourth star. She sat on the sofa and moved her head slightly and slowly, drawing with her nose while aiming down it with one eye shut, with the rule that every other line had to intersect the next to last one drawn. She kept track of all the stars and lines in her head. She started near the middle of the window and moved out-ward, leaping further and further towards stars along the edge of the glass and doubling back, like rings of disturbed water or radar waves, knitting a fractured shape within the bounds of the window's edges. This went on until at some unknown point, exhausted, she fell asleep.

She awoke at nine-thirty the next day. What now? She made coffee and positioned herself for the morn-ing traffic. It was pleasant, not great, nostalgic in a way

that she knew her life was different now. She watched the traffic until nearly one o'clock, content but sad, resigned, thinking.

She ate lunch. Afterwards she sat on the sofa and contemplated the ground. She wasn't going down today. She wasn't going down again ever, until the last time, the hard way. She relaxed there for a while and considered the logistics of hurling herself out of her window. She couldn't just do it.

For one thing, the shallow space of her living room wouldn't allow her to get up enough speed. She wasn't sure how much force it would take to break through the glass but she figured a good bit. She was afraid that if she just threw herself at the window, most of her velocity would be absorbed by breaking the glass, and not enough would be left to carry her body on out into the air. She would probably just snag her midsection on one of the jagged edges and her body would plop onto the shards, gored, half in and half out, bleeding and pathetic. She didn't want that. There would have to be an opening in the glass already.

She had done a lot of thinking the night before and had realized that she wanted two things, two events, to happen. First she wanted a jagged hole in the window pane just big enough for her body to pass through. With this she wanted to get a running start in the living room and dive through the opening like a gymnast or a tiger, clean and muscular all the way to her tightly arched toes, and end up in the air outside, the sky, with not even the slightest scratch on her perfectly honed body. The second part was easy: her subsequent fall to the ground and death. What she wanted within this scenario was a state of grace, a state of perfection and

accomplishment. The thought of certain death didn't bother her. What bothered her was the thought of dying after failing to dive perfectly through the jagged opening of the window, the last conscious effort of her life. If she succeeded she would gladly and calmly fall to her death knowing she had exited her life beautifully, perfectly, as planned. On the other hand, if she failed in her passage through the window, the fall to the ground would be an extended and painful humiliation that would only be relieved by her death. She didn't want her last conscious effort to be incompetent. She didn't want to fall seventeen stories lacerated and bleeding and crying in shame and self-disgust to splat on the pavement a wasted life, a failure.

She thought maybe she should carry a knife or a gun with her, maybe poison, in case she failed. Then she could kill herself in mid-air and avoid the humiliation of the ground. But, she didn't like the idea of suicide. It signified a lack of confidence. She would have to practice the window stunt until she was certain that she could execute it perfectly.

She took a page from the newspaper and taped it securely to the window. She fetched a pen from the kitchen drawer and began recollecting the locations of the stars and the lines she had drawn between them on the paper, until her memory of the game and her memory within the game converged and failed her. She fetched a pair of scissors and cut along the perimeter of the crisscrossing lines, making a jagged hole like broken glass in the newspaper. She taped the shape she cut out of the paper onto the window and taped the remains of the page to a large piece of cardboard she had extracted from the closet. By dinnertime she had

constructed a makeshift stand out of a broom, a sponge mop, more cardboard, and lots of tape, with the broom and mop serving as legs and the piece of cardboard suspended between them at exactly the same height as its opposite on the window. The piece of cardboard looked like a freestanding window, a hurdle, a cruel hoop. It looked like one of those freestanding signs corner delis put out on the sidewalk, announcing cigarettes or milk on sale.

She set the freestanding window in front of her living room window and sat back to admire her work. As she gazed through the freshly cut hole in the cardboard, the jagged piece of newspaper on the actual window fit perfectly into its absence in the model. By positioning herself just so on the sofa she could look at the freestanding piece of cardboard and the newspaper shape on the window in such a way that the shallow space between them was flattened, alternately appearing as if it were either floating in space or not cut away from the page at all. Their relationship was quite mesmerizing.

She ate dinner on the sofa and looked at her plan. While working she hadn't noticed that it was now dark out, and the darkness made the window's surface and the shape taped to it even more dramatic. She admired the shape on the window for a while. The shape had many sharp points radiating erratically from its odd center, yet none of them reached the window's frame. She imagined it as a hole. She took the freestanding window into the bedroom. She admired it from under the covers as it stood near the wall, near the door, casting a slanting jagged shadow on the wall.

She awoke and, after her usual orientations, stretched out on the living room floor to do exercises: situps, pushups, jumping jacks, curls. She had packed her dictionary and several other heavy books into a nylon PanAm flight bag and, having turned her wooden chair around to face the window, sat and did arm curls while watching the morning traffic. The situps and pushups were more difficult, but pleasingly so. After about ten jumping jacks she couldn't imagine what their benefits were, or what they had to do with diving through a window, so she removed them from her program. The situps were particularly relevant since, as she imagined it, she would need to curl into a jackknife position so that her ankles and toes could clear the opening in the glass. This seemed natural because her torso would be losing momentum and falling by then, and by tucking she could leverage her lower legs and feet into the air to ensure their safe passage through the opening. Still, this would take extraordinary abdominal strength and body control. She wished that there was some exercise she could do to strengthen her legs. She rolled onto her back and did a few bicycle pedals but they were even sillier than the jumping jacks. There were leg lifts, but those were for stomach and butt muscles. She decided that she would start jumping rope: good for coordination and quickness and she would need both. She had neither a jump rope nor a substitute, but could easily imagine one and thus bounced in place in the living room twirling her hands and wrists in time with her feet. If she had ever seen or known of aerobics she might have thought about what she was doing, renamed it, or seen it (and herself) in a different light,

but she hadn't, so she didn't. Such was her new morning routine.

After lunch she set the freestanding window in front of her bed with about a foot between the opening and the mattress. She paced off the depth of her living room from the practice window into the hall and placed a piece of tape there on the floor. Then she returned to the freestanding window and adjusted its position so it was exactly perpendicular to her line of approach. In this way her practice situation exactly duplicated where the final event would take place. When everything was satisfactory she returned to the tape mark in the hall. What now? When – how – to start? How do I begin to teach myself to jump through a window? What she was really doing was stalling, avoiding the obvious and discouraging clumsiness that would be unavoidable in her early attempts. She was stuck, frozen by the prospect of her huge and tedious task, the unknown length of time that would follow, and this one and only first attempt, which, however horrible, would be the start of it all. If she stopped now she could come to her senses. Or maybe she was on the very verge of coming to her senses.

She quick-stepped towards the cardboard window, crouching as she approached as if she were about to dive into a grocery bag. She extended her hands and arms and got them through fine, and even her head, but her shoulders caught the cardboard edges and the entire prop crashed onto the bed with her, tangled around her shoulders and nearly destroyed. Shit. She set herself to fixing it.

She tried again. This time she was able to crouch lower on her approach, and she seemed to place her

body on a more level plane, but with the same results. She tried a third time, got better speed with the crouch, and got through the window up to her ribs. Something wasn't right. It was the bed. The mattress was too high. She would have to be moving at some incredible speed to clear the cardboard opening and land entirely on the bed, which was only eight or ten inches below the practice window's opening. The bed was too high to allow for her jackknife and roll. She pushed the bed into the corner and then wrestled the mattress onto the floor. She propped the bed frame on its side against the wall, the boxspring with it, and figured she would sleep on the floor from then on. She stepped back to the tape mark and already the maneuver looked more plausible. She made another run and shot through the jagged opening all the way up to her knees, but caught the backs of her calves as she jackknifed too sharply. Wow! She had almost made it!

She had also wrecked the window in the process, and fetched more tape to fix it, this time duct tape, that should make it last. She figured she might as well reinforce the entire window right then to save time, since it would all probably need it eventually. She very carefully wrapped two of the mangled shards and realized how much she like the practice window, how proud she was of it, how much she enjoyed tending it and sprucing it up. She would wait. She would fix the window as need be and savor the evolution that it would go through relative to her efforts. That would be nice: a recurring intermission to her practice that would give her time to analyze her progress, contemplate her past. Each piece of tape would have a meaning, a history, and would symbolize all her efforts. The gradual application of gray

tape over time would familiarize her with her target and provide an intimate interlude to the demands of her practice. Pleased, she took a break entirely and went to watch the early afternoon traffic. Now, in a strange way, it pleased her how the cars skimmed down the BQE and, after arcing around the bulge of Carroll Gardens, dove into it. She watched until rush hour made this movement erratic.

* * *

By now she had dived through the practice window eleven consecutive times without error. The practice window was almost completely covered with tape, except for a few shards that she never seemed to snag. Interesting. The window had become so coated with duct tape that it had become a blur, an even-handed, hazy memory of a lot in general but little in particular, save the last few failed efforts and the most recent bits of maintenance.

She couldn't remember the exact day she had made her first successful dive. She was practicing as usual and suddenly dove clean through, without any precedent or warning. She spent the next four days attempting an encore.

It was then in a film of despair that she had decided to begin keeping a journal. The mere thought of capturing her daily progress more specifically and accurately invigorated her. Her first entry read:

> Four or five days ago I made my first perfect
> dive. It was sensational and completely
> uncalled for. Since then I have been perform-

ing miserably in its shadow. Now I'm writing it down, recording it, so that I can move on.

And she did. Even on bad or half-interested days in which her form was undisciplined or her approach uninspired she at least took pleasure in writing about the day's events in an attempt to get them behind her. In her journal she could color her actions to her benefit.

Eventually this wasn't necessary as she became consistent and impressive in her practice. Writing became boring and she began chronicling her successes with more immediate charts and graphs, augmented by terse annotations. More than anything she liked the visual impressiveness of bars and lines, sequences and escalations, progress. She liked how one successful dive was doubled in significance by the second, but less by the third. She liked how the likelihood of failure increased with each flawless dive, and yet the significance of each succeeding dive decreased. She liked thinking about that eleventh dive, how it was indistinguishable from the others except for its place in time, which meant everything. It had been eleventh, and could only have been eleventh because ten successful dives had preceded it and the attempt after, the twelfth, had failed. That eleventh dive was special.

That record, though, too, soon fell, and even the records became boring. When dealing with sevens and eights and elevens the records had seemed both attainable and distant, trivial and monumental. When dealing with thirty-sixes, forty-sevens, and fifty-threes, the records were only tedious. She didn't care if she broke them or not. It no longer elated her and seemed merely and boringly inevitable. Nonetheless, when she came

within one or two successful dives of the record (say, fifty-one straight dives) and then missed, she became so furious and despondent that she wouldn't practice for days. On these days she would loll on the couch reading the paper in countless different positions until her anxiousness boiled, at which times she would reel off maddening sets of situps and pushups, hundreds at a time, until she was exhausted, wrung out. She would write out elaborate menus (training table, she had heard it was called) and then have the groceries delivered. She loved fruits and vegetables, oatmeal and rice. In fact, she had become a vegan. She would make lists of observations, things. She would watch traffic or eat or read or go to sleep until one morning she would wake up and obliterate the record by ten dives. Then the whole cycle would start over again. Eventually she stopped keeping track all together.

Over the course of three days she made one hundred successful dives. She kept track in her head. She didn't even try for one-oh-one. It wouldn't have mattered if she made it or not. She had become so familiar with her execution that her successes were wholly expected and her failures immediately understood. She slumped down on the sofa and watched the evening sky dissolve. She would have to get a glass cutter, watch the weather forecasts, move the sofa, organize her journals. . . .

What should she wear?

She thought about the physical reality of her body falling seventeen stories and smashing into the ground. She wasn't concerned about pain, or death, but she was worried that her body might end up such a mangled and bloody mess that her execution, however perfect,

and her body, however honed and flawless, might be lost in the flesh and blood spectacle. What good was death if it only obliterated her final moment of premeditated perfection? She wished there was some way that her corpse could disappear, evaporate, upon impact. Death would become an obstacle when it became known. She didn't want that. She only wanted her accomplishment to be acknowledged by someone, by anyone at all.

* * *

She dreamed there was a knocking. When it came again she woke suddenly, realizing there was someone at the door.

Are you Genny O?

Yes.

They fell silent as their eyes met, a silence made tense by the narrow opening of the door and the chain stretched tightly across it. The young man fumbled for a piece of paper in his breast pocket.

I have the stuff you ordered? From Mazzone's? Can you sign for it?

She unchained the door and took the parcel from him. He handed her the delivery receipt and a pen. Their fingers touched as she took the pen from him. She scrawled her name and handed them back.

Thanks.

No problem.

She laid out the tools carefully on the carpet in front of her along the baseboard below the window sill, and began to etch lines on the glass using the newspaper shape as a template. After she had made an exact outline

she taped the template out of the way, carefully leaving one edge intact in case she needed to double check.

In order to remove the glass from its complicated shape she had to work in sections. She divided the jagged opening into individual shards, creating an irregular polygon in the center to be removed first, followed by each successive shard. Since she didn't want to lose a single piece of glass and risk confusing the investigative process, she attached one of the clear plastic suction cups from the kitchen to each section of glass before making its final, freeing cut. To each metal hook on each suction cup she tied an infallibly knotted piece of string, which she then tied securely around her wrist.

Getting the initial cut in the window would be most difficult. She didn't feel confident with only one suction cup on the entire section. What if the glass splintered? She rigged several more suction cups like the first, lightly licked each, and stuck them to the glass within the etched perimeter of the irregular polygon. She scored three successive edges and tapped with the hammer: nothing. The blows were too soft, and sharper ones might shatter everything. She divided the polygon into quarters, repositioned the suction cups, re-etched the glass, and tapped again. *crack!*

A flat jet of air brushed her hair and face. It had rained the last four days but this day was strikingly clear and blue, the outside air completely washed and fresh and delightful. Outside air! It smelled glorious. How stale and confining her apartment had become!

She tapped her way slowly around the shape's edge until crack and *ping!*

The shape popped out into the sky and air blasted in, disrupting the papers on the table. She neatly fished

the piece of glass back inside with the tethers, being careful not to grate them across the fresh glass edges. It swung in, gleaming like a prize. She detached it and set it on the floor along the wall beneath the window sill, lightly licked and placed the suction cups, and continued. The glass cracked and popped out, more air rushed in (less forcibly), and she retrieved the piece of glass and placed it with the first. Soon the irregular polygon was a torso-sized hole.

The radiating shards were more difficult. There seemed to be no way of keeping their narrow points from cracking crosswise, leaving ugly and annoying fragments in the ends of the points or along their edges. There was nothing she could do about it. She scored and tapped, wrangled and scratched with her pliers, and saved whatever she could. Still, she could see and hear tiny slivers splintering off into the air outside and fluttering down, who knows where. She added to their flight as she filed the odd snags and spurs from the shape's edges, the rasp swirling glass dust in her face as it screeched and grated. The last section at the bottom of the opening popped out cleanly and, playing out its tethers, swung back and clinked against the building's masonry. What a sound! She had never imagined such sounds existed outside, seventeen stories above the ground. All these years the window's tight seal had conditioned her to silence, or at most a dull rattling roar. Now she could hear the tiny, high-pitched scrape of glass on glass as she reeled the final section in. With the last piece she completed the puzzle of the opening's shape on the floor, and taped the newspaper template to the window above.

She moved the coffee table against the wall and cranked out one hundred pushups and one hundred situps in steady, unfrenzied sets of twenty. With a reasonable heart-rate going and near breaking sweat, she moved the sofa out of her path. She stripped down to her brand new, royal purple maillot and did twenty more pushups. She went to the living room's north wall, backed up to it, and comfortably placed her right foot forward. She looked down at her foot and adjusted her toes to the tape mark on the floor. She looked up at the blue square of the window and its subtle, jagged opening. The bottom edge of each shard was reflective and white, while the top edges disappeared into the blue. She looked down again and paused. She sprang forward and looked up at her target, gained speed with four explosive strides and, crouching slightly lower with each step while extending her arms and hands, hurled herself at the window.

She looked underneath and backwards as she jack-knifed to make sure her ankles and toes cleared the opening. Not a scratch. Beautiful. The thing she noticed next was the extreme change in temperature, and then the rushing, rattling sound of air in her ears as her body hurtled down towards earth. She had come through and unfurled from her jackknife but didn't know what to do next! She hadn't thought this part out! She tumbled for a ways out of control and then caught herself, righted up, and fell feet first. Perfect!

She ricocheted through a tree, snapping off a few branches with the force of her body, and crashed through a row of low, dense shrubbery into the bark and soil below. Her heels blasted twelve inches into the rain-soaked ground and her body collapsed and

bounced like a doll. Her hips, jammed by the initial impact of her feet transferred through her exploding knees to her thigh bones, split. Her hip sockets split. Her diaphragm ripped, her ribs shattered, and her spine snapped. Her torso fell backwards into the surrounding bushes, settled, and was still. The stiff shrubbery propped her up and held her like an infant in a high-chair, her muscular arms splayed out over its neatly clipped tops. Her skull and brain had fared fairly well due to the soggy landscaping and the skeletal absorption of her body. She had heard a scream while falling (someone had witnessed her plummet), and it had turned into a sound that wouldn't stop. Someone's chest was heaving and bulging in curdled gasps as they came closer, or got louder, to a certain point. She heard other voices, faintly, getting stronger. Everything sounded distant, frantic. Inside her head and in the air around her there was a continuous sharp ring and low drone. The pain of moving her eyeballs was all that she could feel. Through watery, blood-swollen slits she could see what looked like a small group of people fanning out, jostling, becoming still. Someone hollered in the distance: "Don't touch her!" and then quieter, closer: "Don't go near her."

No one did.

She could hear someone puking. The sound and volume of food in their throat, the timbre of their coughing, made her think that it was the same person who had screamed. Her head lolled forward and she blacked out. No one moved.

CHICK LIT

Genny had always dreaded approaching the row of newspaper boxes down on the sculpture plaza, eighty-nine floors below, down by the tower's main doors. Eighteen – *eighteen* boxes! That had to be some sort of national record – *The New York Times*, *The Wall Street Journal*, all the local papers plus the computer geek weekly, *plus* the *Auto Seller* (Truck version) and then finally, in the ugliest and most soul scarring of the boxes – yellow plastic blow-molded PVC – the dreaded *Singles* paper.

I am not a character in a chick lit book.
I am not a character in a chick lit book.

This was Genny's black secret – that she was, if not a character in a generic early twenty-first century chick lit novel – a cliché. It scared her that her actions were statistically driven and statistically predictable, and that her decisions were about as spontaneous and unique as a third-quarter sales projection within an Excel spreadsheet.

I am me! I have free will! I have spare time and I try to use it wisely!

A flipside to Genny's fear was that the only decisions that people cared about were decisions that had to do with shopping, not her interior world. She envisioned a room buried deep beneath a state like Maryland where a group of men (always men) were assessing the nation's projected need for tampon fibers, acetone for nail polish, ferrous inks for lifestyle magazines. Genny worried that there were 54.8 million Gennys out there, predictably modifying the national economy, their whims dictating the amount of petrochemicals from a Galveston refinery, the number of grape vines planted in Napa, the widening of cranberry bogs in Maine and British Columbia.

And yet Genny *was* a character in a chick lit book. She knew this to be true because one noonhour, after her ten-thousandth trip to the plaza-level Cinnabon for her ten thousandth decaf and cruller, and once back in her cubicle, she felt that magic pull which came from that depressing blow-molded yellow PVC beacon that was the *Singles* paper box – FREE! *Genny! Just open the doors and take one!* Genny knew that if she went and took one of those Singles papers, she was irredeemably Chick Lit. And now, at lunch hour, the fatal moment had arrived. She went to the elevator for the ride down to street level.

Just that morning, with Leila, on the way up to work in the elevator, she'd jokingly tabulated the number of times that speck of yellow outside the tower's front doors had blipped on her mind's radar. She and Leila had also tried to guess the number of times they'd ridden up and down that same elevator. They then multiplied this one-eighth of a mile – and thus figured that they'd been to the moon and back going to work

in their dismal little cubicles. Genny didn't much like her dreary job – a job which, were it to be a color, would be the color of gum stuck beneath a diner counter – not even a diner counter – a diner from the 1940s where the gum came from the mouths of people who'd just dumped their babies on the steps of an orphanage – an orphanage painted the color of gum.

Who am I trying to fool? Don't be such a moron, Genny, it's not too hard to figure out. You don't want people to know you're thinking about dating, which means thinking about sex, which means you don't want people thinking about YOU, doing it, in a plane, on a train, in a box, with a fox.

I am not a character in a chick lit book.

I am not a character in a chick lit book.

She was standing in the lobby. And out there loomed the *Singles* newspaper box, yellow and bland and damning, offering a blank thrill; charged boredom. What kind of guy would put an ad in there? What kind of woman? Threesome wanted. *Slings. Amyl. Latex.*

No. I will not succumb. I am a secretary in a large American skyscraper. Well, to be honest, nobody uses the term secretary anymore. Sexist. Out of date. Beyond even being ironic. It was a dead word. And skyscraper? – even to a relative know-nothing like Genny, that particular expression from architectural history was over.

She neared toward the tower's front doors – smoked grey glass, obviously a guy's fantasy of a macho lobby. But today . . . *today*, in the three hours since since she'd gone up to work, Genny saw that between the eighteen newspaper boxes and the chunk of steel modern art thingy-slash-plaza sculpture, a

crowd had assembled. Why? Certainly not to enjoy the sculpture-thingy – the pointless slab of rusting steel. Ugly. Boring. Alienating. She imagined coffin-shaped oak boardroom tables full of dimwitted executives pretending to understand art. She thought of the laws in that city that demanded that x-percentage of the budget be allocated for art. Obviously, the emperor wore no clothes. And Genny knew, even from her four years at Kent State, that hearing someone discuss art is like hearing someone discuss dreams – you have to be polite, but at the same time, inside your head, you're inventing reasons for why you need immediately flee that particular conversation.

Then she noticed the crowd – the *mob*. Was "mob" an outdated word? What did you now call a collection of angry people these days – an *assembly* of protesters? The language had exhausted its supply of nouns to describe assemblies of the disaffected.

Yes. There was a protest out on the plaza. Angry foaming people, like outside an Alabama abortion clinic during rabies season circa 1996. Many of the individuals holding placards that were actually quite well made – Univers 55 Bold font, well kerned and leaded, and printed with red ink on goldenrod poster board: *Junk the Hunk! It's a hunk of Junk!*

The hunk of junk in question was the plaza sculpture. How on earth could people foam over a plaza sculpture? Sure, it was ugly and stupid and rusting and made anyone who came near to it feel uneducated and dull but . . . it really was a hunk of junk. But so what? What do they want to put there instead . . . a big sculpture of a puppy? Daisies? A giant 1965 Ford Mustang? Plaza art is meant to intimidate people, yet at the same

time make them feel like they're in on the joke: *Hey, you hick! I bet you don't have something as metropolitan and cryptic as this down in Yokelville!*

The police tried to keep the mob of protesters from advancing toward the dismal plaza sculpture. Genny wondered, *Well, short of acetylene welding torches, the most you can do to the slabby metal art thing is spray paint it. Knock it over? In your dreams. It'd take a 767 plowing into Cantor-Fitzgerald to trash this turkey.*

She briefly forgot the dismal blow-molded yellow PVC Singles newspaper box. Something else was happening out there on the plaza – there was a man, wearing nightclubby clothing – definitely not Neil from the payroll, or Marty from HR. He wore a blue silk shirt that dug into his armpits – a bit too young for him – and form-hugging slacks. The Man with the Nightclub Clothing was walking up onto what looked like an Olympic medals ceremonial dais, a pale green megaphone in his hand. *Is he the mob's leader or their enemy?* That much was uncertain.

Genny looked at the crowd. It wasn't a crowd of Gennys, but it didn't look like a crowd of downsized autoworkers, either. They were nicely dressed – Christmas gift sweaters and pleated pants, women and men alike. The crowd looked too smart to be dumb. Too rich to be poor. Too educated to be wearing uniforms. Too bored to be employed. Too needy to be deserving. They were the kinds of people who Genny had seen during her all-too-few forays into the art-demimonde of openings – junkie artists, a few suburban cultural wannabes, so utterly different from those women who ran the galleries, those women who daily ate maybe one piece of Melba toast, two

grapes, and a spoonful of an endangered species so as to stay alive.

The man with the megaphone said, "Everyone, please just stay calm. Everything is okay and we're here to make sure that all of your questions are answered." His voice was matinee idol deep, reassuringly dull yet vibrant.

Oh. A bureaucrat.

"Hello. We – you and me – we are civilized people. We love love. We hate hate. Do you agree?"

The crowd mumbled.

"I said, do we love *love*, or do we hate *hate*? This is a simple question. With your hands, let me know if you believe this to be true."

The crows halfheartedly clapped. The surge towards the pointless metal slab (which had soaked up x-percent worth of the tower's construction cost) had slowed.

"People – citizens – I'm not here to defend my work or to justify its existence so as to please you. . . ."

He's the artist!

"That's not my job, and to pretend so would be ludicrous. I'm here simply to tell you that I'm an artist. I make things that are confusing and frightening, and I make things that even make myself angry most of the times. Tell me, any of you, what sort of world would we be living in if we didn't have artists around to piss us off and make us angry?"

Some wiseacre yelled, *A better world.*

The crowd laughed.

"I hear you, brother, but listen to me, because I've been places you've never been, and you, *you*'ve been

places I'll never be. All we have in common together is that we're human – that we try to change the world in a way that makes it more livable, humane – whatever you want to call it."

Someone shouted, "How about less ugly!"

The mob (crowd) (protesters) – again, Genny realized how inadequate modern language had become in its ability to describe the modern world – cackled.

"Okay, sure, it's easy to trash something you don't like or understand. . . ."

"It's a piece of shit!"

"Sir! Come up here right now."

The mob convulsed in towards itself and focused on Mister King of Comedy who was collectively moshed towards the dais. He seemed dazed by the sudden opportunity to multiply his voice, and visibly flubbered. "Well, uh, *yeah*."

"So what is your point, then?"

"Well, that this thing is an abomination."

"An abomination of what?"

Mister Comedy had no instant response.

The artist said, "I think what you meant to say is that this piece is an abomination of whatever piece of plaza sculpture you had in your head that ought to have occupied this same space."

Genny felt her emotion rising.

"Am I correct?"

The King of Comedy said, "What the hell is this thing? Everyone hates it. Why don't you just scrap it, and put up something good?"

That was when the megaphone died. Unfortunate. Even with a deep matinee idol voice, the FedEx trucks

and taxis and trucks that burped along the nearby streets could drown out the Three Tenors.

The artist fiddled with the megaphone's buttons, and everybody was quite polite, and Genny wondered why it is that people will wait so patiently to hear words they're probably not going to want to hear.

Then an egg hit the megaphone. There was a beat of quiet, and the mob laughed, a nasty laugh – *at*, rather than *with* its stooge victim. Then another egg flew by, hitting the metal sculpture. Its taxicab yellow yolk and its clear glazed egg white stood out like an angry black fly buzzing around a cool, silent dining room. The King of Comedy then said, "Let's charge this piece of crap. Everybody, get out your tools."

Suddenly all of these otherwise unglamorously sensible people came forth with their Picasso and SFMOMA and LACMA cotton tote bags, from which they pulled out chisels and mallets and buckets of paint and drills. There were only two cops present – people with SFMOMA tote bags don't, as a rule, riot. Why would they have needed more?

By this point, Genny realized she was with a different mob, one watching the other mob. It felt like watching the Gulf War on CNN – visual but without physical reality – that was, until one of the rioters tossed the yellow *Singles* paper box at the artist. In flight, its Plexiglas door opened, scattering copies onto the plaza, and were quickly covered with paint and footprints. The corner of the yellow box beaned the artist on the head. He fell to his knees, and without hesitation, Genny cut through the vandals and held him in her arms.

He said, "Keee-*riste*! That thing hurt."

"Get up," said Genny. "Come with me. Now."

The vandals had forgotten about the artist. The sculpture now looked like the Berlin Wall ten minutes before it fell.

Genny escorted the artist into the lobby. He had blood coming down his left temple. People kept their distance, but Genny mopped his blood, and said, "I can't believe they did that. They're horrible."

The artist looked at her and said, "I guess you're new to the game."

Genny said, "I'm Genny."

The artist said, "I'm Kim."

Genny felt a rush of pubescent puppy love, but Kim saw this and before it went any further, said, "Look, sweetheart. Don't get all mushy over the wounded artist. I've been through way worse than this, and by the way, I'm transsexual, and you're a bit too lipstick for my taste, anyway." Kim reached for a cell-phone in a hip pocket. "Thanks for getting me out of there." Kim dialed a number and began talking to someone else.

Genny stood up, took a breath, and walked out onto the plaza, just as police were showing up in force. Ducking a piece of flying trash, she reached down onto the concrete and pulled up what appeared to be the sole remaining *Singles* paper still in readable condition.

I am a character in a chick lit book.

I am a character in a chick lit book.

GENNY O'S OPENING

It is said that Los Angeles is a constellation of navel gazers. A big, hardboiled city paved in Botox. Only this paradise with a lobotomy, this city of fallen angles and fallen art stars could have spawned a woman like Genny O. Without it she could never exist.

It was his first solo show in L.A. and though the red dots were popping up like zits on academy hopefuls, young and seriously restless Drake Payne, or *Dray*, as he was known to his friends, didn't care. He was waiting for Genny O.

He didn't know what she looked like, but idle gossip whipped his casual interest into frothy peaks. There were the tales of men who threw themselves at her feet, the immolations, the drive-by shootings, and the tantalizing tidbit of her legendary virginity.

Tess, his smarmy dealer, assured him that Genny O would be at his opening. "She'd *better* come," Tess cooed. "It's her gallery too."

As the gala wore on, however, Dray was beginning to wonder.

Tormented by his fears, he ambled through the
clutches of well-wishers and rivals with a certain swag-
ger forged by years of skateboarding, Xbox playing,
and surfing. A shock of flaxen hair fell over his right
eye or what he liked to call his *naked eye*. He pushed it
aside, not with vanity, but with the same unconscious-
ness that informed his belching. Loose and low slung
jeans conformed to his lean athlete's build and revealed
an enticing inch of red satin loincloth above his metal
studded belt. Collectors, artists, and the mere art-curi-
ous beheld the denim trousers as they bunched and
released below his back door then crept their licentious
orbs back to his stellar face. There, spelled out in the
silent but universal language of facial features was a
giddy fusion of strength and sweating bullets.

A collector in her mid-thirties with a bare midriff and
a MBA's sense of art cornered him and gushed, "Dray,
where *do* you come up with your ideas? I *loved* your
Mortal Combat series, but *Morpheme* is even better! Tell
me you'll paint another *Kid on Level Three with Cellphone*.
It's divine. Also *Air Cheeto* is wicked. That cheeto will
forever be out of his reach, like that circle in hell."

Admiration succored him. Dray looked at his
unscuffed Tigers. Someone licked his arm. High heels
and a word chain wrapped around a stocky ankle. It
was Tess.

"Dray! Every piece sold. People even want to pre-
order work. And a museum hopes to make ashtrays
out of your crow's feet. . . ."

Tess's puffy red lips continued to move over her
Chiclets-white teeth, but Dray stopped listening when
the energy changed in the crowd. Dray knew *she* had
arrived.

Which one? Which one is she?

Then he saw her. Not what he expected, but even rather than. She was a wisp of a thing with preposterous curves and wide-scattered eyes. Each eye was so far removed from the other that they seemed to be looking at two entirely separate eye-charts. Dark eyes filled with savvy and framed by a wealth of hair extensions. Her attire contrasted with her mien of a thousand sorrows. Over her body language she wore skintight muslin, rife with unnecessary straps and bands. The dress broke at the waist into an A-line mini that accentuated the deconstruction of her buttery-smooth legs. She was ne plus ultra and everything about her bespoke confidence.

And she's still a virgin! Dray snorted.

Many thought her to be a sort of female Samson, deriving her power from her hymen's precious feathering of flesh. Jealous women dispatched their most seductive men in efforts to coax that layer of epithelialized connective tissue away from her, but they always returned, ciphers, tails between their legs, or once (as legend had it), in a box.

Genny met his eyes. *Damn!* She thought. *He's gorgeous.*

The Atkins-thin young man under the shiny mop of fair hair vexed her. His impeccable grooming at the UC Institute of Art and Design threatened her standing at Masterstroke Gallery as the youngest and extremist artist. Green as he was, his cod was undeniable.

Tess, eyeing swinishly, pushed toward an untapped collector. Soon a pocket of dumb luck opened up around Genny and Dray.

"Nice show," she said in a voice both warm and sibilating. "It's a good follow-up to the *Gettin' Busy in the Back Seat of Dad's Golf Cart* series."

Drake coughed.

"I'm Genny O."

"—?"

"I know, it's a name that's hardly there. I was born with it. Our family name used to be O'Malley, but back in the days when being a Mick was nervy and they were getting 'Paddy-whacked' and all that they decided to make their name sound less Irish by dropping the Malley. So what do you think of it here?"

Dray slid his right index finger across the underside of his current *Artforum*.

"Honestly, I don't know why I go to these openings any more either. . . ." Then Genny gave Dray a furtive look. "On second thought, perhaps *this* time I do."

She nodded to the cabal gathering that peered back at them from behind their invisible shields. "The gossip's already flying. That's all they do is talk! Talk! Incessantly talk! Sometimes I feel like they want to see me *as I am*. I can barely leave my bungalow any more. But, no matter how excruciating it is, we *must* go out in public and we *must* show our work to the lumpen-proletariat, and, at times," she gave Dray an Altoid, "we *must* share our hearts, right?"

Dray's eyes followed the complications of Genny's top down to her plier-like legs.

"You're not like them, are you? There's something about you, your work, that puts me at ease, and deballs me. It's almost as if you are ravishing my thoughts. Have you ever felt like this before? All poufy-like?

Listen, since it's your first show here I'll fill you in on all the people who are going to be a total waste of your time. Okay, the jowly guy in the flip flops is Bill Bates. You know the work, Home Depot on acid but with angst? His stuff's a one-liner or maybe only half a line. . . . Black pants suit at six o'clock is Ginette Hinter. Don't talk to her – ever. Really. She uses *theory* in her work. I always tell her to try using *art*, but she won't be helped. Okay, that freak over there is Jonathan Cost. He does the whole cult of personality thing, thus his potty mouth. Hell-*o*? To *be* a character one must first *have* character. He's at that little bitty gallery next door, but between you and me he's getting dropped. Little-Miss-Trying-*Way*-Too-Hard in the who-me? boots is taking his place. Typical stuff. Young woman exploring narcissism and WMD. No man ever gets tired of pretty girls who make naked voodoo dolls of themselves. That cameltoe with the lumpy boyfriend commits the worst of all possible art sins. She makes art, not even about beauty (which is bad enough), but about *artists*, closing the shitty solipsistic circle of the so-called 'art world.' Art about art is like sewing your anus to your mouth."

Dray chewed on the inside of his cheek.

"I'm sorry. I go on and on, but you shouldn't get me started on these things. I mean, none of these people make *actual* art. They make things that maybe *look like* art and sells like art, but not one of them has that crucial ingredient needed to make art: the hook. Their alleged art sells alongside *real* art as if *they themselves* were real artists, but of course they're just *total* and *utter posers*. And there's always a market for desire posing as art. After all, some critics make entire careers out

of supporting *non-art* and dealers, collectors, and curators are *heavily* invested in *non-art* and are in fact up to their nipple rings in *non-art*. And not a one of the *non-artists* dresses like an artist because dressing like an artist requires that you empathize with something that extends further from the self than the tip of one's own nose!"

Dray muttered something, which may have been, "Harsh!" but was more likely the sound of him clearing his throat.

Genny threw her arm around their dealer, "I *know*. This is the precise reason that the art world is such a sinkhole. Everyone's terrified of loosing traction. The non-artists are sure they'll be revealed as e-pinions, so they try to deflect their deception onto others by spreading sick rumors. For example, I bet you heard about the 'Genny O situation. . . .' Lies. They make those things up because they're *total* liars. Their *sickness* is *spoiling* art for everyone. They're truly mentally ill. *Sickness* in the form of non-art is dictated to us by mentally ill non-artists *and then* that very sickness somehow gets spun into success. Museums, galleries, collectors' homes are all *plagued* with the afflicted stench of twaddle. And why? Because they're alleged *art stars*. And the *real* artists making *actual* art (not the smoke and mirrors that only *approximates* art), the *real* artists can't get any traction. It's a sausage factory."

Dray raised his eyebrows and stifled a yawn, which Genny O took to be a sign of sympathy.

"Stupid me! I know what you're thinking." She pulled him to another corner of the gallery as he tipped a C-shaped hand to his open mouth at the smartly dressed gallery assistant in hopes of getting a drink.

"You're probably wondering about all of those spicy stories about me. Listen. While I *did* cut the finger of one of my assistants and while it *was* accomplished in anger, it was *not* done on purpose, as the fiends are so fond of saying. And it was really only a blip. She didn't even stay over night at the hospital, the drama queen. What else? Let's see, no – to the urophobia. Yes – to the penchant for silk and burlap underwear thing. No – to the guy jumping out a window for me thing. Yes – to the virginity thing and a definite no to 'the Genny O situation.'"

The tapioca faced assistant brought Dray a plastic cup of cheap white wine. After giving her a wink and a nod, he finished it in three gulps.

Genny grasped his free hand and voiced goo-gooly, "There, now that that's out of the way, we can have a real tête à tête. I know, I'm ranting again, but really, look around. Who am I supposed to talk to here? I spend all of my time just cogitating and *cogitating* and *cogitating* about the whole rigmarole and the urgency just *mounts* and *mounts* until I think I'll stamp my foot! You know, it's funny, I really thought I'd pooh-pooh you. I guess because of all the jaundice. It's stupid, isn't it? That we should be in competition with each other? Here we are face to facelift, two people with more in common than most. I mean, you don't use antecedents, do you? Neither do I! And yet the very nature of the art world would have us tear at each other's Asics Tigers."

Dray gazed around as he toyed with his empty plastic cup.

"Should we get a drink? There's probably something stronger in the office. No, over here," she

dragged Dray, who seemed to be lurching in the opposite direction, to a back office lined in art magazines, show announcements, and breadbox-sized artworks.

"So, do you think I'm . . . hot?" Genny asked as she sank in the camel saddle behind the desk and pulled a bottle from the top drawer. "You do. Hmm . . . good whisky. Two fingers or three? Suit yourself. People like us are doomed to be despised. To be loved from afar, perhaps, but never *truly* loved. I know. I speak like a diva. It's really difficult to see the world as I do: in terms of movement, light, and space. I was reading Milne the other day. . . . Did you know that he was a firm supporter of bears? Anyway, I believe it was he who said, 'Artists are to honey as love is to flies.'"

Dray tipped his drink back and set the empty cup down. He then draped himself over the desk, closing in on Genny's four fingers.

"More whisky? I thought so. Anyhow it hardly matters if you don't believe in power, I mean love. I'll tell you why, but first – I feel frisky asking this – could you come with me to the bathroom? No, I don't need to throw up if that's what you're thinking. I could put you to better use than a hair holder anyway. It's just that this is the first time I've really felt like I dialogued with anyone in ages and I just don't want to interrupt the simpaticoness. Break the spell. Hold on. I'm bringing the bottle with. Now where was I? It *is* like a spell, isn't it? A yoga spell. Oh well. Come on in. Don't be bashful."

Dray opened his mouth in protest.

"Hey, come on!"

Giving him a final tug toward the bathroom, Genny O slipped in and locked the door behind her.

She sighed and let her body collapse against the cool surface of the door.

"Alone at last."

She pushed off the door to the toilet. White panties with a graphic of a cupcake on the front dropped around her ankles.

"No. No need to turn away. Just because I'm a virgin it doesn't mean that I'm a damsel. Actually, can you run the water? It helps, I don't know why."

Genny's head ducked between her legs and she peered intently into the toilet bowl.

"Isn't it strange how clear your urine is when you drink? It's almost as if drinking was the inspiration for minimal art. . . ."

When she finished, Genny O drew a paper towel across her mouth. She then rose and stepped out of her panties. They lay on the ground in the form of a sideways eight: ∞, suggesting to Genny limitless possibilities.

"Okay, here's the plan. I'm going to take a pill. It helps me to reach my inner artist. (It also helps with my ADDD.) Then we are going to kiss."

Someone knocked at the door.

"*Shut up out there!* We're in here! Honestly, you'd think people would be less needy.

"Let's see, red, pink, blue. . . . I think a lavender pill, don't you? Oh! This L.A. water is shit! Here, taste it. No, like this. I'll wet my finger and you lick it off. Brilliant. Yes. Just like that. I can see you've done this before. Uh! My mouth is totally sour. Good thing I brought the whisky, right?"

She took a swig from the bottle.

"You want some?"

Dray didn't respond.

"Okay by me. . . . Now for that kiss. No. You stay there. You look blackalicious like that. I'll come to you. Close your eyes. Just kidding. I hate that! Hmm. Goody. I can tell you've been properly kissed.

"Ugh! Enough with the knocking! As if this is the only bathroom in a five-mile radius. Forget them. Now it's just you, this toilet, that graffiti, and me.

"What was I saying? Oh, yeah. Shall we try a kiss again? I *am* ga-gaed by you. It's nifty. Being here. Together. Under lights that make me look fabulous. And yet it's so obvious. Too obvious, you think? Sometimes meeting expectations is the last thing people expect. Here. Help me take this tape off. It will help me think if I can stand in the au naturel."

The dress fell from Genny's shoulders and formed a perfect "o" around her high heels. Clad only in goose bumps, she swung her hips significantly from side to side.

"Naked at last. You like my body? It *is* precious. I can say that because I only speak the truth and modesty is for wannabes. This body is the reason I have to talk incessantly – or anyway, part of it – I've got to constantly remind people that there's a whiz-bang brain at work behind my beauty. God! They're still knocking, as if we *chose* to be here. There's no choice here. We're not so dim that we can deny these feelings. We are only followers of amour. How should I know what we are?

"Please, just promise me you won't listen to them. I mean, perhaps it's true that I've been the monster, but never the way they said it. Everything I've done, I've done with style, nuance, and brio. Was I so wrong to accomplish all of my desires? Even the monstrous ones?

"And them! Those ideologues outside the door! They're idiots with their idiot lives and their idiot boxes and idiot savant. *He's* an *idiot*! The ability to recognize *real* beauty, *real* art has long ago been obfuscated by Dummies books and theory. I've never read a Dummies book and I never will. This door is our gallery, keeping the blooodsuckers at bay. We are *artists*! They *willfully* inflict their mediocrity on us? What do they think art is for? *Ironing*?

"These people, these studies in sfumato, they actually think that *they* are the artists and *everyone else* is the poser. And they're nothing! How do you defend yourself from nothing? Zero? How can we protect ourselves from parasite assistants who are stealing our ideas? How can we even create under these circumstances? That's why my studio's a black hole, sucking every ounce of light out of me.

"You're in perfect accord with me. Love could only be wanton and savage between those of different stations. But it's never naughty when it's the love of equals.

"I'll speak no more of love. Artists should reek of nothing but art. And when she makes art she should make art and nothing else, not even horsies. That's why I can't love you (though I fear I already do). . . .

"My assistant doesn't know the meaning of Lacan. It's not like her hand doesn't function without that finger. Besides, she'll never make anything relevant anyway. She'll only show in the *fly over* states.

"Now, touch me! My still waters of pain. Hold me and we'll drink to our bods. And tonight, when they're gone, we'll say goodbye. But for now, we have ourselves, our bodies. It isn't art, but perhaps it's what I like."

Genny stole one last kiss from the mirror and began to fill the sink. Bending over to pick up the empty circle of her dress made her dizzy and momentarily silenced her. She dipped her throw-up-stained garment in the sink, rubbing the soiled spots together slowly as the fuzzy twinkles faded before her eyes. When the last star fell from her vision, she once more mingled her solitary commentary with the intermittent pounding on the bathroom door.

FIREDANCE

Even her thighs were wet. Her back was sticky. And her mouth was dry. She hated flying. Especially in economy. The flight was overbooked so they downgraded her. At the time she didn't care. She just wanted to get away. Away from L.A. Away from him. With two hours to go before landing in Hawaii, she regretted not having waited for the next flight. Too late. Funny enough, that's what she said to him when Paul apologized, "Too late."

Now she was on her way to Hawaii with only one thing in mind: holiday.

"Aloha, pretty lady." The tanned Hawaiian boy with no shirt smiled at her as she stepped off the plane. His bronze skin shimmered in the early afternoon sun. The naked skin of his muscular forearms brushed over her shoulders as he gently lay a band of flowers around Genny's neck. It was a brief encounter but long enough for her to feel the heat of his body. The moment passed. She already felt better.

Ever since she saw the lei boy, Genny felt a tickle in her lower region. The tickle lingered even as she entered the open air lobby of the hotel. Tall gaping windows looked down into the resort gardens where cascades ran into pools of glistening water. Genny stood at the railing, mesmerized by the view and the calming flow of manmade waterfalls. Drifting with the streams, her mind flooded with images of the lei boy . . . plunging into waves, making love in wet sand, his head diving between her thighs, pleasuring her, waves of ecstasy surging through her as the ocean breaks over their bodies, her lips parting with orgasmic screams, silenced by the sound of the sea.

Genny got a bit of a shock when her mind's eye saw the lei boy rising from the surf and realized . . . it was a different man! Powerfully built with defined features and a dazzling glint in his eyes. The vision faded and Genny opened her eyes. Like a rush, she felt the most powerful moment she had ever experienced. For there he was . . . in the flesh! Standing below the balustrade, in the gardens, framed by hanging leafs of tropical plants. He looked like a statue of Adonis, the god of love. His enigmatic eyes looked right at her. It was as if their spirits had merged and his image had entered her daydream by the power of his desire for her. Genny bit her lower lip, spellbound by the force of the moment. She smiled. The statue smiled back. Genny knew the boy from the airport was a fantasy, a delight of her imagination. This man was real.

"The luau starts at five. Are you a guest of the hotel?"

Genny turned, still captivated by the ethereal encounter.

"The pina coladas are the best." The lady at the activities counter winked at her and handed Genny a leaflet.

"What's a luau?"

"It's a must! We have an exotic buffet, open bar, and live island music," the woman answered.

Genny's heart jumped when she saw the luau leaflet had a picture of him in it! Adonis in the flesh. His bare chest tilted backward as his hands twirled a ring of flames around his athletic frame. In the gardens he was wearing an open shirt. The leaflet showed him in all his manly glory.

"The fire dancers are hot," the activities lady teased. "Your heart will race when you see Nakana command his fire stick."

Genny looked up, sparks in her eyes. "I want a table right next to the stage."

The air was still hot, though the sun had merged with the ocean right after the buffet was served. Genny was on her second pina colada, taking in the dance number. She had spent the afternoon unpacking and strolling around the hotel. She had bought a new bikini and a skirt. Revealing but stylish. For a brief moment, when in the store fiddling for her credit card, she had thought of Paul. She imagined the look on his face, the blank stare as he found out what she did. Guilt invaded her mind and she took a long sip from her drink.

Then the stage went dark. Drum beats resonated with the stars above in a primal rhythm, like the pulse of the island, profound and mysterious. As the pace picked up, Genny's heart started pounding. Blood flushed from her toes to her waist, heating her core with burning desire.

"Ladies and gentlemen of the Princess Wailea Resort, our god of fire is called Lonomakua. And he has bestowed his gifts on the man you're about to see. He's a master in the native art of the fire dance. Please welcome . . . Nakana."

He appeared in front of Genny like a dream materializing from her heart. A wave of heat surged into her face as Nakana handled a stout pole with fire-spitting tips. He spun the fire stick around his body, a ring on flames slicing thru the darkness of the night. The drums picked up, raising the ecstasy in her blood. Genny had to hold on to her drink with both hands in order to keep her fingers from slipping under her skirt. Temptation trembled in her like a bonfire and there was only one way to put out the flames.

The fire dancer bent backwards, the ripped muscles of his abs shining in the glow of his fire pole. Spinning the ring of fire over his chest like a scorching halo, Nakana moved across the stage. Genny could feel the heat getting more intense as the man edged closer and closer to her seat. He was only inches away. The flames thundered over her head and she could feel the strength of his thighs as his legs touched her skirt, like steel pressing against silken skin.

"Don't be afraid," he whispered his first words into her ear while still handling the perilous fire pole over their heads.

"I'm not," she replied.

"Then dance with me."

With that he held the burning pole with one hand, spinning it even faster. His free hand grabbed her by the lower back, lifting her out of the seat with a commanding pull. Their gyrating hips joined

in natural rhythm as if a magnetic force was fusing them together. Genny could see the faces of the audience flash by. The world around her became a blur.

Nakana guided her onto the stage. He was a demon stealing her away, except she wanted to be captured. Genny's eyes opened wide when she felt his thrust between her thighs.

"Don't be afraid," he whispered again.

Genny was seduced with lust for this man, taken over by his powers. The people in the audience watching their hypnotic dance game, unaware of the intimacy between the two players, became nothing but a distant memory in her mind. With every beat of the drums his pelvis pounded into her. Genny's head fell backwards, gazing at the stars through a spinning disc of fire.

The applause of the ecstatic audience snapped her back to reality. Back into her seat, sipping her pina colada, watching Nakana perform on stage, dancing so far from her.

The show was over and the lawn was cleared. Only a few busboys hustled around, cleaning up empty cocktail glasses. Genny walked away from the luau lawn and stepped onto the beach. The cool sand relieved the soles of her feet. But her inner soul was still yearning. Gazing at the distant horizon, she thought of everything that happened before she left for Hawaii. What a mess. A hot sting stabbed into her shoulder blade, and she figured it must be stress. Her hand moved to rub the strain away and she shrieked . . . as her fingertips touched the warm skin of a man's hand on her neck.

"Don't be afraid," were his first real words hushed into her ear. Genny knew it was him: Nakana.

Again he had made her dream a reality.

Genny moved to turn around but he held her back.

"I was looking for you ever since I saw you at the lobby gardens," he confessed.

She never felt at ease like this with a stranger. Then again, he didn't seem like a stranger but more like a soulmate. "I was at the luau," was all she could think of to say.

"I know," his voice made her shudder, vibrating every sense in her body. "I saw you."

Before she could reply, his sizzling hands moved over her hips and down her thighs. His fingers penetrated the fine silk of her panties, lighting a fire inside her that burned hotter than the blazing volcanoes on the Big Island. The surf of the black ocean washed ashore and over her feet as Nakana's hands sent tremors through Genny's inner core. She could feel his groin.

This is what she had waited for all her life. Twenty-four years she had saved herself for the right man, the right moment. That's why she had left Paul at the altar. She did not want to lose her virginity to a man who smelled of beer and peanuts every Monday night.

This was the perfect moment. She was not going to let it go. Genny's blouse ripped open as she spun around and charged Nakana passionately. He was surprised by her eruption. . . . No woman had ever taken charge of him like this. The moon emerged from the

dark horizon, shining its pale silver light onto the rousing waves, like sparkles of diamonds.

As their bodies fused into one, she felt his throbbing muscle inside her core.

"Go slow. It's my first time."

"We can take all night," he promised. Even the surf calmed down, as if the island was in tune with the fiery lovers on its beautiful beach.

Nakana kept his promise. After hours of passionate lovemaking, Genny woke up in her room, an exquisite suite overlooking the ocean. She could see the beach from her balcony. The spot on earth where Nakana had transformed her into a woman, the happiest woman on earth. The warm morning breeze wrapped around her like a soothing towel. That's when Genny realized she was naked, standing on a balcony overlooking a fully booked hotel!

Excited by her own carefree mind, she leaped back onto the bed and rolled herself into the sheets. She saw the note on the phone.

"Meet me for breakfast at the cabana."

Genny's head sank into the pillow, unaware that her lips were touching Nakana's love note. She felt heavenly. The phone broke her moment of bliss with a shattering ring.

"I don't care why you did it, I just want you to come back." Paul's voice sounded more whiney than threatening.

"How did you get this number?"

"I want you back, please."

Was he crying? She sat up, surprised how calm she took the unexpected call. After all this was a new Genny. A Genny in love.

"That's the problem, Paul. You never care why I do things, or how I feel, or what I mean. As long as I'm on your side, dolled up and ready to blow." She swallowed hard, shocked by her own rude wit. There was silence for a while.

"Why did you do it? Why did you embarrass me in front of two hundred guests and a priest?"

"Because I don't love you . . . enough."

"I want you on the next plane. There is a flight leaving at two o'clock. I'll pick you up at LAX."

Genny rolled her eyes.

"If you're not on the plane, I will cut you off. No more BMW. No more 'Help the Children.' No more Mr Nice guy." His words made her stomach cramp up, a pain she had not felt since she landed in Maui. Now it was back. He was back.

"The flight leaves at two o'clock. You have three hours." Click.

Nakana fed her fresh pineapples. Lying on the beach, they had their late breakfast in silence.

"Are you all right?" he asked.

She could not answer. Instead she slipped into his arms, her head resting on his chest. She closed her eyes, listening to the waves.

When she woke up, a spurt of fear ran through her body. Was it just another daydream? She opened her eyes. He was still there. Stroking her hair tenderly, Nakana looked at her like he had looked at her the first time she saw him.

"Are you all right?" he asked again.

"What time is it?"

"Two-thirty. You slept over an hour."

The faint sound of a distant airplane passing high

above the clouds could be heard. Genny smiled. The feeling of bliss from this morning came back to her. And with it the teasing tingle between her thighs.

"Yes. I'm all right."

O APPRENTICED TO X

Genny O, a girl of some mental capacity, apprenticed herself to the master artist X.

She was motivated and had always known that only the genius X would suit her prodigious ambitions. Her interview with him had consisted of some brief questions into her background and prior artistic encounters. These were not worth describing. What impressed X were the lengths to which she had gone to find him. She had traveled a great distance alone, left without the blessings of her Romanian family, and had found the means to station herself in the vicinity with a finality that left few other options for her should he not accept her as his apprentice. X also felt aroused by her shadowless gaze, which, he believed, entirely concealed what were surely the dark motivations that had brought her to him. "You have a secret," he had probed. And she had responded that she did not.

He had asked her then about her interest in performance art. And he had asked her whether art revealed, concealed, or perhaps shaped truth. She had

looked at him that day with a steady, open gaze that hid nothing and yet revealed so little. X could not hide his anticipation to begin her training at once.

Indeed, she had had little exposure to artistic experience of any kind and had few preconceptions, but her physical presence was remarkable in its sentient intensity and her desire to learn was formidable. So her apprenticeship began.

He was delighted to have such a dedicated and attractive pupil and sought at once to cultivate her own unique viewpoint.

"With young women," he would say, "it is necessary for them to develop a distinct sense of their sexual power and to clarify their desire openly. This is how they will develop the strength to support their artistic integrity."

So saying, he brought to her a wide variety of erotic literature and imagery that he had collected from his world travels and began her education. His strategy was to expose her to a spectrum of sexual positions – both physical and conceptual – to dissolve her unexamined preconceptions about gender relationships, expand and excite her vocabulary, and to awaken an exploratory attitude uninhibited by the sexual mores of the time.

These were always related to their social-cultural context, their political implications, and their economic dynamics. They looked through frames of power. They speculated about possible future sexual relations – reading science fiction and theoretical texts. They considered the way the body is seen, framed and photographed. They studied anatomy – in depth. They looked at possible manipulations and alterations. They visited plastic surgeons, tattoo and piercing parlors.

They examined body decorations from around the world and studied scarification rituals. She learned massage techniques and experienced the different energetic and emotional potentials of stroking, shaking, and application of pressure points. She was exposed to the pleasure of food and spirits and learned of their aphrodisiac qualities.

Throughout this period, she kept her virginity intact and kept a devoted and monastic routine. Lectures, discussions, and field trips took place in the morning. This was followed by a private studio practice where Genny O was encouraged to observe, touch, and activate her own body. She recorded these sessions on video – practicing framing herself – and watched them all later, sometimes with X, who would discuss other possible ways of approaching her erotic inquiries and keep her practice close to a rigorous critical discourse. In the evening she would research special topics. Or sometimes she was allowed to help in X's studio. It was here she could observe the great artist X erect and perform increasingly ambitious projects. He worked exclusively with the hierarchical interactions of power and was inexhaustible in his pursuits. He attempted to manipulate the "power caches" of generationally compounded iniquity and the oppressed vitality of individuals. "Energy is the medium," he would say to her. She herself would be weary by nightfall, but X insisted that before bed she spend an hour each night fantasizing. Sometimes he would suggest a topic, or provoke her with a kind of koan. "What do you love enough to die attaining?" "What is revealed through concealment?" Other times he required her to cultivate an improvisatory

and free-associative framework for her musings and this was where she excelled. She was always challenged to understand her own desire and the secrets that motivated her. She was encouraged to whisper her secrets to the night. Genny O had no secrets, but she withheld this information.

X, touched by her dedication, was nonetheless disturbed by her inability to feel infatuated with anything – not even his own unique potency. Discouraged, he felt at one point that this refusal to focus her considerable energies around one love object threatened his entire pedagogical project. And so a search began. He had access to beauty of all kinds, and these were summoned as instruments for her erotic projections. Men/women in many forms: noble, sadistic, sickly, strapping, attentive, receding, and all with fetching hormonal insistence, were brought for her examination. Genny O thought it best to listen to her heart. As each one was presented, she monitored her blood pressure and the pulse of her right and left wrist to observe if anyone at all could affect her. To everyone's dismay, she remained unmoved.

The pleasure she did experience was in being seen. She opened her skin to their embarrassed, curious, ravenous, or disdainful eyes. It wasn't their subject-driven gaze, rather the sensation of being held in the world visually that engaged her. She got the same pleasure from random, non-sexually motivated brushes with strangers in a crowd, with tall grass blowing, with the wind itself. But she began to imagine her own gaze never being able to land. Doomed to wander. The blankness inside her presented itself. Because it had been her natural state, only her studies had brought it

to her attention as a problem. Awareness clustered around a bias in the teaching of X. She grew increasingly uneasy with the knowledge that her passion, though real, was abstract. She was excited by the ground, by a frigidly clear sky, by great heat that strained her heart, by snow, and not by a person who was near, mortal, and able to be changed. This setback only intensified her commitment to her art.

She kept six notebooks, each with a different title:

Sex and Death
Sex and Life
Sex and Ecstasy/Freedom/Spiritual Power
Sex and Power
Sex and Connection
Sex and Schism

Here she placed articles, photographs, and notes from her studies. Of course, many practices transcended categorization or were found to apply equally to radically opposite perspectives. For example, Japanese love suicides as well as seroconversion practices registered in both the Sex and Death book and the Sex and Ecstasy/Freedom/Spiritual Power book. Snuff and rape belonged to Sex and Death, Sex and Power, but also to Sex and Connection. Pregnancy and family belonged to Sex and Life as well as to Sex and Power. Romantic love belonged to Sex and Connection, Sex and Schism, and Sex and Ecstasy/Freedom/Spiritual Power, as did anonymous sex.

She became interested in the erotic uses of abstinence for their ecstatic spiritual potential. But equally intriguing was the compelling power of the imaginative register within the concept of romance. The more she studied anatomy, and the immediacy of violence and

power as acted on the body, the more she recognized a beauty in the combination of body and imagination.

She followed the fetish culture with something approaching passion. Sadism was transformed through imaginative scripts, language, and costume. In carefully framed situations, partners could willingly participate in roles they otherwise rejected allowing them to experience psychological complexity.

At night, she was torn between developing a love object around which sexual energy could crystallize and exponentially intensify, and creating vast abstract landscapes for the free play of erotic psychological concepts. She imagined every kind of person and every kind of animal, but somehow a genuine love object – with its ability to create its own erotic weather system – did not emerge. Although X pressed the importance of the love object, she found herself unable to obsess about anything except the further mastery of erotic concepts.

She worked so diligently, however, that X became excited by her progress. She was able to recognize both the relativity and the specificity of sexual mores – their connection to power structures and to ecstatic literature. She was bold in juxtaposing value systems of vastly different contexts. Although timid and uncertain in the beginning, she quickly found confidence in her inquiries and explored her topics with a directness unusual in a novice. X eventually retreated from his insistence that she directly activate the subjectivity or even the objectivity of a person, to let her develop what appeared to be conceptually-driven motivations in an as yet unknown form. Over time, he began to regard her as his best pupil.

"A prodigy," he would boast, with a wink as he sat at night with the aging patrons of his endeavors.

Finally it was time for her to complete her apprenticeship. This would be done with the creation of her own project. She soon recognized that the project she wanted to undertake would, in fact, culminate in a sexual act – her first with a partner. After some deliberation she discussed this with X and he agreed to assist the project himself. Other participants were also persuaded to help. Costumes were bought, apparatus constructed. X advised her that this project would require her to either reveal, conceal, or shape truth – and that if she committed herself fully to this, secret aspects of herself might float to the surface of her work. Genny O, who was not sentimentally attached to the concept of truth, could, however, not see how its presence or absence would affect a secret she did not have. In spite of this, she did worry about exposing her essential blankness, and so she made a last attempt to incorporate a love object into the work. Understanding this as a crucial animating principle, she examined the participants for any suggestive threads that might bind her heart. She studied their strengths and recorded their hardships and weaknesses. Systematically, she coaxed out each of their painfully guarded secrets – all of which were disappointingly ordinary. She spent time fantasizing about X as her love object. She understood the power of teacher-student relationships and knew how to manipulate the myth of the schoolgirl, but it didn't excite her. She thought also about dominating him. Toyed with the concept of the young girl destroying the master. This had some appeal, but never to the point where she felt she could enact this obsession with

artistic integrity. In the end, she resolved herself to creating an abstract script operatic in scope. A script of erotic tasks.

The performance begins with a blue room and a landscape of cocks. Men lying on their backs creating a field of bodies. O walks through this field and tends to the crop – stroking or sucking the cocks as she goes. The shafts rise and perhaps fall and rise again. The task is to have all cocks blooming. At first the men are passive but as they become increasingly aroused, they can assist her efforts by masturbating. The audience is attentive. She is joyful as she directs this movement to self-fulfillment. She regulates the tempo and pays special attention to any cocks that may be having trouble. The cocks are highly responsive – waving in the air like stalks of wheat. She is dressed in a short full skirt and a blouse with an extremely low-cut neck line to give it an ethnic, Rhaeto-Romanic quality. The scene has a freshness to it – a young woman in harmony with nature. She even sings to herself as she works. When all the men's hands are moving rapidly, creating a kind of gentle percussion, she leaves the scene. The men climax as she walks away.

She enters a Romanesque doorway just to the side of the blue room. A brilliant light draws attention away from the field of men. Inside is a small, intensely lit office. An examination room. X is there and requests that she remove her clothes. He does not turn his gaze away as she does this. He watches intently. Appreciative murmurs from the audience as her heavy corset falls to the floor. When she is naked, she climbs onto the medical table. She is given two oil crayons – a purple one and a yellow one. Centered behind her head is a table with an iris. X stands at the other end of the table, opposite the flower. With her feet on the table, knees bent, she spreads her legs symmetrically. She holds the yellow

crayon in her right hand, the purple one in her left. X begins to touch and manipulate her anatomy. As he activates an area, the folds of her labia, for example, O draws the response it has on other areas of her body with the crayons – mapping out an energetic anatomy of her sexual pleasure directly on to her flesh. Although X works in a primarily symmetrical manner, the maps are asymmetrical and O tries to notice whether her consciousness of sensation has a left- or right-handed orientation. The different colors reveal this. X takes his time and activates many different parts of her anatomy – her lips, her thighs, the insides of her forearms – but, of course, he spends the most time with her clitoris and inside her vagina. The methods of activation vary, and each one provides a different map. Almost immediately, O realizes they will need to separate the maps, and so an elaborate cleaning ritual is enacted after O has determined that a drawing is finished. A photographer records the maps. A warm rough cloth is used to wash the crayons followed by a delicate drying period with the entire cast blowing the moisture from her body. The process is enjoyable, relaxing, so that O begins to lose all anxiety about correct response to stimuli and can simply experience it. X is attentive and skillful in his manipulations. They are both excited to see how the drawings develop. As she becomes more aroused she uses the broad sides of the crayons, rubbing them over her body and coating her skin with oil color.

After thirteen drawings, X helps her up and removes his own clothes. Her skin still bears the final drawing. Holding hands, they tiptoe into a large new room with a small glass booth in the center. The room holds many naked couples, each moving closely in different formal dance styles. Two men, their foreheads touching, entangle their legs in an erotic tango. A short and muscular pair fall and twist in

tight, athletic circles. Another couple sweeps through the space grasping each other's waists and hands. Motion is understood through the friction and impact of flesh, and each choreography includes all manner of foreplay. Periodically, couples abandon the dance floor and retire to the well-lit glass booth to practice their particular dance form in a horizontal format. Although they do not actually engage in intercourse, their doomed attempts to recreate the dances have a sensual and at times comical frenzy. The audience laughs. X and O begin a delicate court dance side by side at first, and then with a brief, flirtatious side step, O passes to X's other side. They continue their exquisitely polite movements traveling circuitously towards the booth while the dancers around them escalate their labors into an intoxicating group romaika.

A Change in Scripts Resulting in a Fatal Setback and a Somewhat Mitigating Revelation

X makes a sudden coercive shift in the scene by ordering her into the glass booth. This is not in the script and O is initially confused. She refuses to go. She is indeed alarmingly empowered. The audience leans forward in their seats. Her sexual energy is stunning. When it is clear that the dancers intend to physically oblige her to accept this change, she fights with untested vigor. She is enraged by the violation of her concept. Nevertheless she is eventually overcome by their naked strength. "You haven't yet realized," X says once she is in the booth, "that this is actually my production." He points to the audience sitting outside of the glass. "They are here to see my work." O looks out into the audience. Old men, all, with their decrepit cocks glistening in their hands. Yes, this is not her audience. He has stolen her work. She

grasps abruptly the truth of the moment. This is not art. This is not why she makes art. She tastes anger and her knee jerk response is appropriately directed. X is prepared and avoids injury to his oeuvre. She goes for his eyes but is corporally subdued by her complicit colleagues. Although fury is with her, her surprise devastates effective response. She is pinned to a counter, her ass exposed and her head against the glass.

She stares through this transparent border with astonishment. Her project – the culmination of her young life's efforts and the first true expression of her desire – is being perverted, annihilated by the man she believed incapable of such treachery. The Artist. And she knows then that he is nothing of the kind. The stage lights are bright upon her darkest moment and maybe it is the transformational capacity of high wattage tungsten that changes her heart. Or maybe it is the presence of one man who sits amidst the ejaculating seniors but seems to be somewhere else entirely. Love, she realizes with a start, animates her quest to be an artist. This new awareness infiltrates her orientation. It courses through her intellect – illuminating the blankness until it shines as bright as blindness like a mirror in the desert sun. Love, latent, awaiting its catalyst. Hiding in the unacknowledged fusion of sight and being. The alchemy of art and audience. The realization is so absurd to her – given her present betrayal and exposed condition – that a short, sharp laugh bursts from her compressed throat. She studies the unusual man in the audience who smiles so gently in response to this. He is both delicate and strong with Romany features. She cannot interpret his expression – somehow deeply sexually interested, somehow dreamy. Very kind but stained with darkness. Their eyes lock and she feels her throat drop between her legs. An explosion of warmth

and feeling in her genitals, her own diaphragm impairing her breath. Her face pressed hard against the glass, her blood saturated with adrenaline, she experiences a moment of total quiet except for the ectopic beating of her heart. Fate, the master Sadist. She thinks Sex and Schism. She thinks also Sex and Connection. Her love object. She has found him.

X enters her hard and fast in one brutal thrust, smashing her virginity to satisfy his art. Bravos erupt from the audience. O transfers her violation into connection with her mysterious love, for upon seeing her scream in pain and rage he has also begun to masturbate. The expression of his passion is gorgeous. Still fucking her, X grabs her throat with two hands and begins to press her windpipe. He says, "a secret's power is lost to life but with the bearer's death it becomes an energy source." She shakes her head vigorously, gagging. She wrenches and contracts her body in wild articulations of cellular freedom. She rips at his hands with her hands. Her eyes, straining in their sockets, seek those of her love. Does he love her? Will he help her? She thinks Sex and Death. Sex and Death. And he is ecstatically aroused. Her fury. Her desire.

COITUS INTERRUPTUS - A DIVINE INTERVENTION

It happened at that moment that there was an earthquake of some magnitude. Violent, the building's structure was damaged enough to create a believable distraction. Genny O was able to escape and plot her now-famous revenge on X. Although she lost sight of her lover, and in fact, swore malediction, she retained and developed her capacity for romantic projections onto alienated audience members. She denied all

involvement in X's interrupted production – which nevertheless received some good press. Her renown as a performance artist surpassed that of X in spite of a resurgence in his popularity after his death. The notable developmental consequences of her salvation via unexpected catastrophe was, of course, her emergency-contextual projects which sought the transformational capacities of an audience's panic and confusion while romantically engaging a single ecstatic spectator. And love, her previously unimagined truth and the secret she had kept so successfully from herself, became the dominating theme and core of her artistic oeuvre, of which we are all so familiar.

DOGSBODY

Dogs. They are better than human beings because they know but they do not tell.
— Emily Dickinson

Genny O was awkward. Not difficult, but ungainly and guarded. Painfully shy, Genny knew people's shoes better than their faces. Mundane actions such as walking through a restaurant or boarding a bus were excruciating for her. At these times her movements grew clumsy, her heart raced, and her cheeks burned in humiliation as she recoiled from even the most casual glance or look of mild interest. It wasn't as though there was anything about her that would cause people to stare. She was attractive, agreeably turned out. But while she was small in stature, Genny felt as though she took up too much space, as though somehow she was always in the way. Her inability to articulate her thoughts without stumbling over her words made conversation a constant challenge and she felt a keen sense of failure in her relationships with others.

Despite her awkwardness, Genny O was pursued by men who saw potential in this enigmatic, withdrawn girl. Their advances, however, did little more than illicit acute embarrassment, for Genny lacked the ability to flirt or act coquettishly. Superficial relationships held no sway with her and she resolved to wait for someone she could open herself to, someone she could trust with her innermost thoughts, her deepest secrets. And Genny had a secret, one so terrible that to her mind the thought of someone discovering it made her recoil in dread.

Perhaps from spending so much time looking away from people, Genny had developed a growing affinity for dogs. With them, she felt completely at ease. Able to let her guard down, the anxiety and prickly tension would ebb away. She loved everything about dogs, their uncomplicated natures, their willingness to accept without judgment, their lack of duplicity. She wasn't partial to any one breed. Large mutts, purse-size pure-breds, even genetically modified dogs that managed to be gleeful despite their lack of hair, or tail, or the ability to breathe properly. All were dear to her, and if she could glimpse one dog amid the human sea, it gave her strength and pushed some of the painful self-awareness away.

While she longed for a dog of her own, circumstances prevented Genny O from fulfilling this desire and so instead she made them the object of her employment. Genny walked dogs, dog sat, groomed and washed them. Immensely popular with her canine charges, her reputation grew until she had ample work to keep her busy. Genny coaxed a reluctant Bulldog to take a turn about the park each morning and read to a

nervous Borzoi while its owner ran errands. She fluffed and preened a pumpkin-colored Pomeranian who loved to be told of its beauty, and wrestled with a Retriever who would eat anything and everything that came its way. Genny loved that she smelled of wet dog, had mud-streaked paw prints down her legs, and was accessorized more often than not by a wad of plastic waste bags protruding from her pocket.

One day, Genny was called by a man needing a groomer for his dog. The caller explained that it was somewhat urgent as the dog was to be photographed later that day. Having just returned from an exhausting session with a recalcitrant Standard Poodle, Genny was in the process of stammering out an excuse when something in the man's voice made her change her mind, a combination of warmth and authority which she found compelling. And so, within the hour, Genny opened her door to the most remarkable creature that she had ever seen.

The dog was strikingly handsome. Tall and lean, it had the sporting body of its Wolfhound breed, all sinewy muscle and restrained energy. It had beguiling eyes that exuded a keen intelligence. Genny knew that she would not have to cajole this dog into accepting her ministrations. She bathed and groomed it, taming its course wiry coat. As she talked quietly, the dog gave her its full attention, looking into her eyes as though it understood everything she said. The Wolfhound had an imposing self-assurance that Genny yearned to possess. Long after it had left with its owner, the dog's spell over Genny remained. She felt as though she had been transformed, as if some profound change were in motion.

The following week, Genny received a call from the same man asking for her assistance. He explained that he was artist and that his dog was to be the subject in a new series of photographs he was producing. It was a complicated undertaking and he needed someone to lend a hand, someone who was comfortable with dogs. Despite some trepidation, Genny accepted as she had continued to think often about the captivating Wolfhound. In fact, she couldn't get it out of her head. She dreamt about it at night and conjured its image in her head while she went about her daily routine. As she dragged the overweight Bulldog along each morning, she imagined what it would be like to have the Wolfhound loping at her side. She couldn't help but compare its poised self-control to the giddy energy of the Poodle, its simple beauty to the fussiness of the Pomeranian.

And so Genny found herself at the artist's studio. Discovering the door ajar, but too shy to call out, she shuffled uncomfortably in the doorway. A loud bark was followed by the appearance of the dog, its tail wagging in greeting. Though she avoided the gaze of the man who followed behind, the dog's obvious pleasure in seeing her again helped put Genny at ease. It was as beguiling as on their first meeting, its eyes filled with the same perceptiveness. It walked companionably beside her as the man showed her around and discussed details of the work at hand. The studio was filled with photographic equipment, backdrops, and a myriad of props. At one end of the large room was an elaborately constructed imitation of a natural setting based, so she was told, on a nineteenth-century painting. The attention to detail was impressive. The scene

had the same curious merge of realism and artificiality that Genny had observed in the dioramas at the museum. When he was ready to begin, the man positioned the dog within the tableau, arranging its head, body, and legs until he was satisfied with what he saw through the camera lens. Standing to one side, helping when asked, it was clear to Genny that the dog was completely content. For while the flash of the strobe light made Genny jump, it seemed to animate the dog in a discernible way. He played to the camera and it was fascinating to watch.

In the weeks to follow, Genny began to play the part of assistant with growing ease and enthusiasm. She enjoyed the challenge, the sense of camaraderie, and the feeling of accomplishment she derived from working in the studio. She still dragged the Bulldog on its walk each morning and saw to her other canine commitments, but she spent increasingly more time in the company of the artist and his dog. She remained aloof, though, observing the proceedings until needed or talking quietly with the dog. But familiarity had caused her to become less nervous around the man and Genny had to admit to herself that she admired his way with the dog. It was clear that they adored each other.

The dog would do anything for him. The ideal artists' model, it tolerated his every whim with infinite patience. In his dealings with Genny, the man was gentle and respectful and she, in turn, felt the sway of his influence and found herself trusting him more with each day. Over time, Genny came to understand the rhythms and idiosyncrasies of life in the artist's studio. She could anticipate his directions and read his moods

as well as those of the dog. When she was with them, she was happy.

It was a sweltering day, one of the hottest of the year. When Genny arrived at the studio, she could hear the drone of fans pushing at the stagnant air. The dog was sprawled on the floor panting. It lifted its head in greeting, but couldn't muster the energy to get to its feet. Instead, Genny bent down and ran her hand down the length of its side, feeling it rise and fall with each quick breath. Going to the sink, she filled a large bowl with cool water. Placing it on the floor for the dog, she dipped her fingers in and absently trickled the water down her neck and over her collar bones. They wouldn't have been working in such heat if it hadn't been for the upcoming exhibition and the need to finish the new series in time. Genny sighed, the heat, the quiet of the studio broken only by the hum of the fans encircling the room and the tranquil panting of the dog was hypnotic. She felt as though there was nothing outside this room. The world beyond its walls had ceased to exist. She lifted her head and saw that the man was quietly watching her. Rather than flushing with embarrassment, a wave of pleasure washed over her. She held his gaze before looking away.

Under the studio lights, the heat was crippling. Getting the right atmospheric effect was crucial to the latest photograph and achieving it was proving to be difficult. The oppressive conditions necessitated frequent breaks for the dog's sake and in one such interval, as she watched it nap peacefully, Genny proposed that she act as the dog's stand-in during the infernal process to alleviate its discomfort. And so, mimicking the dog's stature, she took its place under the blinding

light. The novelty of the situation eased the mood and soon both artist and substitute model were smiling and laughing. Genny found being in front of the camera surprisingly exciting. After a lifetime of attempted invisibility, this shift was a little intoxicating, and she began to understand the pleasure the dog experienced when the eyes of the man and his camera were fixed on her.

The shoot went more easily after that and by the early evening they were tidying up and preparing to leave. The air was still heavy, but the searing heat had abated once the lights had been extinguished and there was the promise of relief from a slight breeze that had begun to blow through the open window. Long shadows were forming, the corners of the studio growing dark. The dog lay contentedly under a table watching them move about the room. Damp with sweat, her dress clinging to her slight body, Genny was folding some discarded fabric when she was startled by the touch of a hand placed gently on her back. Turning to face him, their eyes met before their mouths eagerly followed. The kiss was deep, passionate, and Genny lost herself in it, forgetting to keep up her guard. It was too late. He ran his hand down her back and before she could stop it he had paused, then come to rest at the base of her spine. Genny broke away in panic, fear and humiliation overwhelming her. She rushed for the door, but he caught her hand and pulled her to him. Holding her in his arms until he felt her relax, he then turned her around and gently lifted her dress above her waist. There at the base of her spine was a distinct lump, a distended coccyx bone, whose presence Genny had desperately hidden from the first time she had been taunted as a child. The man studied it momentarily and

then turned her toward his smiling face. Expecting to see revulsion, Genny found admiration and love instead. As they kissed again, Genny O knew that her secret was safe with him and that she would be his forever.

HOT STUFF

*It's best to wear a knee length skirt, wide at the bottom (an
A-line, it's called) . . . and knee-high boots, but not panties.
All natural fabrics – because they hold in the heat without
igniting. Hold the heat.*

*It's only from practice and practicality that she knows
this.*

*If caught at the scene, boots now hide evidence of raw
shin skin and healing scar tissue, so as not to send up any
red flags to the extinguishers or investigators. With this
new uniform, she can get closer to the flames while still
having easy access to herself in standing position for the
duration.*

*Years ago, she'd wear flip flops or sandals so that she
could feel the warmth crawling up her legs and under her
skirt. Beginning from the tips of her toes, it slowly became
a little hotter, a little less bearable, and finally encouraging
her to hurry up, hurry up. By the time the most intense
heat reached her face, she'd finished herself off.*

*In those days, she had hair on her legs. When she felt
the overwhelming need to ignite, she'd skip shaving for a*

*couple of weeks beforehand so that it would grow out long
and thick.*

*The planning of every detail is so important. The more
complex she can make it for herself, the more she can drag
out her anticipation with these little teases – the sweeter her
satisfaction in the end. The smell of her burning leg hair
was intoxicating, a sweet mix of sulfur and almond oil.
Every time she smelled it, she became quickly aroused. She
imagined that this must be what it's like for a man when
he feels himself becoming erect. And like an aphrodisiac, the
smell lulled and seduced her into a kind of erotic paralysis.
It's funny what turns people on.*

Genny took a deep, sad drag from her Gitane, still
holding the match that lit it until it burned down to her
fingernails, creating a putrid, familiar perfume. She's
been watching him for months from this same window.
It's eight feet high and five feet wide, with a seat that's
two feet deep. Her loft is drenched with sun from
morning until night and she loves to sit here all day like
a lazy cat. She made a fluffy brown, suede cushion to
fit the space. It's a cozy spot to write and wait. Because
she's small, she can lean up against the inside wall on
either side, or have a nap in a slightly bent position. But
mostly, she sits straight-backed facing the window, fac-
ing Thomas.

She knows his schedule. He comes in at eleven a.m.
and leaves at six p.m., except for Thursdays and
Fridays, when he leaves at five. On the weekends, his
hours are irregular – and it's really frustrating, so she
doesn't watch. His routine goes like this:

#1: walk the bike through the front door, coffee in right hand

#2: swallow two aspirin tablets (he seems to have a lot of headaches)

#3: turn on his computer

#4: turn on his stereo system, insert CD (He's been playing the same CD with the bright orange cover for two weeks now, but she can't make out what it is from so far away. She considered buying binoculars . . . but that would make her crazy, rather than just curious. Instead, on the third bright orange CD day, she went to Virgin Megastore and casually perused every CD cover for a few hours. Narrowing it down to twenty-seven bright orange possibilities. Each time Thomas puts in the CD, she puts in one of her selections at the same time. If he has to walk over and change the disk before her music stops, or if her music stops before he changes his disk . . . then it's the wrong one and she considers it for the reject pile. But, this can become quite confusing, because it's possible that when he walks over to the CD and presses a button, he may be replaying a favorite song. Or sometimes, he walks over and presses a button before talking on the phone. Is he turning down the volume, switching off the CD player or pressing pause? And does he wait in silence after the CD has finished playing or does he always change it after the music has stopped? It's really impossible to tell. If his windows were open it'd be a lot easier. Anyway, it requires patience and focus – like all successes.)

#5: sit at his computer and stare at the monitor, typing for about an hour (probably email)

#6: change out of his street clothes and into dirty, yellowish, canvas overalls (on cold days, he wears a

sweater beneath. On hot days, he's shirtless. It's warm for November and his radiators must be on, because he's shirtless today.)

In September, she noticed the name on his mailbox is Thomas Sullivan. He's tall and his body is lean and sinewy, but he's not skinny. His shoulders are wider than his waist, and his ass is narrow and roundish. Kind of like two pound cakes side by side. He has the long, lithe limbs of a dancer and a virtually hairless chest, save one dark patch of curls in the middle. His skull is rounded and a tad pointy at the peak, with dark, close-cropped disappearing hair and sometimes rectangular, black-rimmed glasses. Thomas has a famous-face with a sharp jaw, straight nose, and big faded green eyes. On the street, people probably think they know him. And his hands are massive and surprisingly smooth looking for a sculptor – a perfect complement to his deep, calm voice. *He really is stunning. Plus, the fact that he rides his bike everywhere, ensures that his muscles are hard and his skin always a little flushed and shiny.*

She's fantasized about Thomas since that party at Robert Miller's massive apartment five months ago. She was only at the party because of Martin, her boyfriend who is an art critic at a newspaper. Martin is more full of shit than originality, with a knack for descriptive, objective writing. His editors love it, because he never puts opinions in his work, just the facts and references, surrounded by carefully crafted, flowery adjectives. Genny hates parties, is terribly shy, and always ends up drinking too much to conceal her

social anxiety. But Martin had insisted that she go with him because he just couldn't show up alone after the opening.

"Genny, it would be social suicide. You know these people can be piranhas," he'd said. "If I go alone, I'll look like a reject. Please, please, please come with me. It'll be fun."

After the shameless pleading, she agreed to go.

As Genny looked around Miller's palatial home that night, she gained a new perspective of the art world. She began to visualize each group of people as having identifying shapes.

All of the artists had puckered bodies. Their yoga bums sticking out round in the back, turned up and ready, their chests pushing out for display and consumption. Sideways s-curved spines everywhere. She imagined giant hands coming down from above, manipulating and molding them for the evening – their backs and fronts made from mounds of warm dough that had been stretched almost to it's snapping point and then popped back into place, a little more exaggerated and swollen than normal.

All of the collectors, dealers and critics seemed lurched over on top and tilted in at the bottom, fragile structures. c shapes – their shoulders leaning in to reveal perfectly starved-on-the-right-foods collar bones and their tails protectively tucked under with crotches sticking out. The shapes became a visual metaphor for each person's status at the party. It was blatantly clear who was doing the fucking and who was getting fucked.

It was depressing to see s- and c-shaped people wandering around bumping into each other with their

butts and bones begging. Bouncing off of walls and egos. An overwhelming, dizzying experience to view, which made her feel nauseous.

She worried about the authenticity of these people she'd admired.

She'd always thought of artists as burning with passion, needing to create something greater than themselves and stewing in their genius. In fact, her favorite people had always been artists of some sort. In grad school, they were the most open-minded and independent students she knew. Driven by their obsessions and too focused to care about conventionality or social structure, they seemed fearless. Although she'd been too timid to be a part of their world directly, she loved being an interloper.

But that night on the Upper East Side, she was made aware of their desperation for attention and was simultaneously sickened by it and glad she'd chosen to keep her most important work private. She got drunk and tried to ignore the artifice of the scene and tragedy of having her ideals debunked.

Maybe it was N.Y.C. that did this to them, she wondered. *The competition forced them to become prostitutes.*

Wandering over to the buffet table, tipsy and blue, she eavesdropped on conversations.

"For me, painting and sculpting and remembering and feeling are the same," she overheard an artist whose work she did not like say to a well-known group of collectors.

"Polysyndeton," Genny quietly slurred out. She remembered studying this concept in a linguists class. The artist's boring language trick worked on the crowd. Tightly pulled, octogenarian mouths

salivated over him as he exited one group to work the next.

Thomas was working as a cater waiter at the buffet table and standing nearby, looking just as dejected as she felt. He heard her drunken slur.

"Polysyndeton it is . . . yes, well a little linguistic manipulation never hurt anyone. And if you don't have nepotism on your side. . . ." He paused.

"Or talent . . ." Genny quipped.

They bonded instantly, laughing at their crassness and quietly sharing that it was uncool to be bitter at a party like this.

"I'm just glad to be here!" Thomas said with a sarcastic smile. And then tilting his head from side to side, and using a really great Valley Girl accent, he said "I'm like, totally networking this scene, babe."

Genny laughed and said, "Plus, I can tell you're not a C or an S."

He paused, looking confused.

"What did you say about CVS?" His brow furrowed and his green eyes pierced into her.

She was so distracted by his dark, long lashes that she couldn't think straight. And even though it was a simple inquiry, he looked darkly intense when he asked about the pharmacy. It excited her.

"Uhhh, nothing . . ." too long of a pause, "I just mean that . . ." too long of a pause, "well, anyway, I've got to go now."

She freaked out. He was too smart and beautiful.

This was the first time she'd felt sober all night – and the first time she'd been *really* turned on by a man. This handsome, funny, cater waiter seemed to have more perception and humility than anyone she'd spoken

with that night. They never exchanged names or numbers. Just a few sentences and a lot of pheromones. She didn't even learn that he was an artist until later that night on the way home.

That's when she first met Thomas. Right there by the crab dip.

As Martin drove her home that night, she asked about the cater waiter at the buffet table. He was typically paranoid about her inquiry.

"Oh, that guy, he's nobody, an artist. Not famous yet, but talented. He'll probably be hot one day because he's good looking and knows the right people."

"Why was he working as a waiter?"

"Genny, not everyone has the luxury of pursuing their passions full-time." Martin took every opportunity to point out that she didn't have a job. She guessed it made him feel superior in some upper class-guilt sort of way.

"Have you ever reviewed his work?" she asked.

"No, he hasn't had a solo show yet, and I don't review group shows, Genny," he smirked.

"Well, do you know his name?"

"Why are you so interested in him, Genny? He's an artist, you know how they are. . . . He's probably a self-involved sex addict or something."

Martin was the king of bitterness. They'd met in grad school while taking a writing class. Although he likes to think that he's "a gifted and perceptive writer," the truth is that he's a mediocre journalist – a private reality that makes him feel insecure and angry most of the time. If his family didn't own half of the publishing

world in New York, he'd probably be working in the accounting department of some gardening magazine.

"You don't have to get upset about it," she said. "I was just curious because he was really nice to me," she added to calm him down.

"Look, he's an asshole, okay! There's nothing mysterious about him. And he wouldn't be interested in you anyway, because you don't put out."

She knew it drove Martin crazy to think about her being interested in anyone but him.

"Forget about him, baby. Think about me," he cooed, switching to his sad little boy face, trying to stay on her good side.

"Martin, I don't put out *yet*. I'm waiting until I find someone who can handle my fire." She winked at him, playing his game, trying to flirt and avoid a fight.

The double entendre was completely lost on Martin. Even though they'd been dating for eight months, he had no idea about her impulses to set fires, no clue about her past, and he wasn't perceptive enough to pick up on the signs. She'd decided long ago that it was best to keep this most powerful part of herself secret from people. No one understands why she does it, why she can't stop doing it, and why she's obsessed with it, so it's pointless to bring up.

When she was a teenager, her parents had sent her to a group home for "firebugs," as the other kids called themselves. She had set the family home ablaze. Genny claimed that the whole thing was a mistake. If they hadn't found her lying down and masturbating in the backyard as the whole world went up in flames, they never would have known it was her.

She was able to convince her counselors that she was just scared about the fire and not excited, that she was holding her crotch to keep from wetting herself, not jacking off. Consequently, she was "cured" and released after six months of perfect, non-caustic behavior and thirty thousand dollars in insurance money. It had been a terrible embarrassment for her family and so no one ever discussed it. She learned to keep her desires private. If no one knew, no one got hurt.

"Oh, baby's got fire inside, huh?" Martin oozed. He took his hand off the wheel, slid it under her silk skirt, and between her legs. He awkwardly wriggled two fingers into her while trying to maneuver down Fifth Avenue.

"No panties as usual . . . and you're wet! Why don't I come in for a while before going back to the hotel and we'll fool around," he suggested, his eyebrows raised.

"Actually, I don't feel so well. I'm too drunk and tired. You know I hate parties, Martin."

"I don't understand why you won't let me fuck you?" he burst out, his fingers still sliding in and out of her. "Don't I treat you nicely? Don't I leave you alone when you need to write? I mean, plenty of women would love to be Martin Maddigan's girlfriend." His fingers picked up pace and force at the mention of his name. She guessed that he was getting hard, which meant more of a struggle than she was prepared to deal with tonight. She tried to calm him down.

"You know why, Martin. I'm not ready yet," she whisper-sighed, faking pleasure.

She let him continue finger fucking her as they approached Chelsea, oohing and ahhing to make

him think he was getting closer to his goal. In her drunken state, it did feel sort of good to be penetrated. She closed her eyes and thought about the cater waiter.

The phone rang. Genny jumped off her window perch and ran across the room into the kitchen.

Caller ID. "Helloooo, Mother dear!" she chirped.

"Hi, darling. How's my little girl?"

"Oh, I'm good. Just researching for the book."

"Well, good for you. How's that coming along?"

"Fine, going well. I should be done with the first draft by Christmas."

"Great. Speaking of holidays. Are you bringing that charming Martin to Boston for Thanksgiving?"

"Oh, I'd love to, Mom, but Martin wants to take me to Connecticut to meet his parents," she lied.

"That's my girl. Get yourself a husband before you get so old and decrepit that no one will want you. Fair-skinned people don't age well, darling," she said, then laughed her horrible cigarette-wheezing laugh. "And another thing," she added, "wear a dress for chrissakes and don't overeat, you were looking a little fat the last time I saw you. They only need one butterball on Thanksgiving." Wheezing laugh again.

It was amazing how quickly this woman could go from fake-supportive to abusive control freak.

"Mom, that's my other line. I've gotta go, it's probably Martin. Love you."

She hung up. *Goddammit. Matches, where are the matches?*

She looked at the installation on her living room wall across from her front door and took a deep breath.

"Oh, never mind," she said aloud.

She's never considered marrying or having sex with Martin. The only reason she dated him was because he was the one person she knew when she moved to N.Y.C. Because of her strict Irish Catholic upbringing, he probably assumed that she wanted to wait until they were married.

She didn't hate the idea of sex and she wasn't afraid, but until Thomas came into her life, she'd never imagined a more pleasurable experience than the one she has when she pleases herself in front of the heat and power of her fires. She knew that Martin had other lovers. This was purely a relationship of convenience for them. He liked how she looked and what she represented to his family and friends. She liked that he kept her legit with her parents, and therefore, independent of them. But she would never love him. He was too much like her mother, controlling, possessive, and cruel. He acted as if he owned her.

Last week, she found Martin's diary. She hoped to see some indication that he might be creative or talented or at least harboring some deep, dark secret. Maybe she'd find some juicy sexual exploits that would arouse her more than finger fucking and insincere suggestions. Writers are notorious for dissecting and exploiting their lovers in print. Sadly, she'd never seen such a pathetic example of this cliché until coming across what she assumed to be a draft for Martin's "Great American Narcissist Memoir."

Each chapter was titled and dedicated to a different woman. Chapter three, was entitled "Red Hot" and

described every inch of Genny's body, every superficial quality that could have been ascertained from casual observations. It was horrible, resembling a written version of an anatomical diagram, embarrassingly objective, and shockingly unpoetic in its attempt to encapsulate her. But she ripped it out to save, because no one had ever written about her before as far as she knew.

It read like a perverted, tight-assed grocery list:

- Met Genny O'Leary at Harvard
- Art history major, with a minor in literature, like me
- Medium length red hair
- About 5'5"
- Brown eyes with tiny specs of green
- Small features
- Porcelain skin, flushed red cheeks (maybe high blood pressure?)
- Pussy smells sweet and metallic
- Small forehead, dark eyebrows that don't match her hair – but later learned that her hair isn't dyed because her pubic hair is also red
- B-cup with hot pink nipples and aureoles the size of quarters. Nice!
- Taut tummy, but pooches out at the bottom when she sits in the tub (needs to do more sit-ups)
- Ass is high and bubble-shaped
- A few crooked teeth on bottom, but otherwise good (braces could correct)
- Unattractive scars on the front of her legs – she says from a car accident (could be remedied with p. surgery)
- Sucks a mean cock, but won't put out . . . yet . . .

And so on. It was a really boring read, which was probably why Martin wasn't a novelist. *Poor, untalented Martin, completely without passion,* she thought.

The night she found the diary, she set his house on fire, which is why he currently lives in a hotel.

No one was hurt in the fire. He lived alone and was out for the night – but that awful book was surely put to death . . . save chapter three.

She's absolutely extraordinary at her pyrotechnique (as she calls it), because she's been practicing sneakiness all her life. She only sets fires when she's angry, bored, or feeling like a failure. She can usually contain her impulses to start them, but once they get going, she always gets so excited about how powerful it is that she just has to touch herself. That's been the hard part. She doesn't want to leave the flames until she comes and in N.Y.C. the firefighters are so damn quick about getting to the scene that she has to be careful. They know that most pyros can't resist the temptation to satisfy themselves in the presence of a job well done.

She's been good for a whole year . . . except for Martin's place, which was totally justified. Oh, and that one slip up five months ago – but it wasn't her fault, really. She awoke from a terrible dream and had to do something.

She'd dreamt that a fire in her loft had forced her out of the window and onto the ledge of her building. She carefully balanced there naked, her arms spread wide open and palms flat against the cold, rough surface. She was clinging to the crumbling red brick as

tightly as she could with her fingertips. But as the wind picked up, her dick started to get hard. And as the blood rushed through her, the weight of her own cock became so heavy that it pulled her off the building, sending her plummeting to her death.

As a condition of her freedom from the family, she has to see a therapist until she's married. She always chooses the most clueless ones, so that she can keep up her work and not be distracted by self-discovery – a sure-fire killer of creativity. Just look at anyone who's ever read *The Artist's Way*.

Her sliding-scale shrink at the time said, "Sounds like you have a little bit of penis envy, Genny."

What an amateur, she thought.

"Well, who doesn't?" she said. "Do you live in America? Have you turned on the television in fifteen years? Apparently, it's the best thing going . . . who wouldn't want one?" She stopped seeing him the following week when he'd suggested that she was aggressive. Clearly, he didn't understand a thing.

It's a shame about his car, but honestly, maybe a good walk will give him time to think about making snap judgments about people.

She thinks of her work as pathological performance art. She could never tell Martin this because he claims to know everything about art and is far too critical and rigid to accept what she does as potentially creating rather than just destroying.

Thomas would definitely understand her, judging from his artwork. It's amazing that he moved in right across

the street from her, like fate. Since starting his latest project, he's been in the studio more often and working later into the night.

After hanging up on her mother, she sits very still, smoking and watching him across the alley. Thinking of ways to get his attention, to meet him.

He seems so incredibly focused as he fumbles around with his designs. He's in the planning stages, the part she likes best. He must model with clay first because his sculptures are expensive and time-consuming to produce. They really have to be perfect. His fingers move fastidiously over the damp clay, massaging the crevasses and teasing the peaks. Brightly colored plastic pieces are strewn here and there around the studio. It amazes her that someone so meticulous and precise can be such a total slob. The detritus of former projects and the dead carcasses of unrealized ones lie in every corner, heaped in piles without any sense of hierarchy or importance. She loves the democracy of it all.

The one finished piece sits on a table near the window facing her, like a beacon. She saw him test it last week and has been dreaming about it ever since.

It's a bright red, orb-like plastic or fiberglass object that spits, of all things, *fire!*

It rolls around on the ground like a Ben Wa ball threatening to ignite anything in its path, turning on and off randomly. Very dangerous, but exciting, too, and pretty.

Thanksgiving is the worst holiday when you feel alone.

Martin was meant to arrive at four p.m. She's already pissed off about having to be with him, but the

fact that he'd insisted she cook a turkey was inconceivable.

He told her, "This is going to be a special night for us – very intimate."

She knew what he was talking about and it made her want to vomit. Her plan had been to tell him that she was going to Boston, order Chinese take-out, and spend the night reading.

Instead, she hurried to get dressed. Brown silk, diaphanous blouse with embroidered burnt orange and red leaves. On bottom, brown wool skirt, A-line. She had work to do tonight. It was time to put the bossy, boring boyfriend out of his misery.

She had everything timed just so. She'd fake an accident in the kitchen, which wouldn't be hard because she can't cook. As soon as the stove was on fire, she'd force him into it. The whole incident should be over by five p.m.

Martin rang the buzzer at six-thirty. He smelled like booze.

"You're late."

"Oh, sorry, love. I had to make a stop at this dealer's house. He was having a big bash today. I knew you wouldn't want to go. Not your crowd."

"I don't have a crowd, Martin. In fact I don't have any friends, haven't you noticed?"

"You don't need friends, you can use mine." He grinned a weird, lascivious grin and grabbed her by the waist. "Oooh, sexy shirt, baby. Are you trying to seduce me, Mrs Robinson?"

"Good god, you're so corny."

"Look, don't be a cunt," he snapped, and then softer, "I was trying to flirt with you, Sweetie.

Besides, I'm horny. How about a little BJ before dinner?"

Nina Simone played in the background. Sadly, sweetly.

"Listen," she started, "I don't want to fight. Let's just have some turkey and call it a night. I'm really exhausted."

He came closer.

"Okay, but how about a little BJ, Baby, like I asked?"

"Martin, I've been cooking all day and then waiting for you. I'm not in the mood to suck your dick right now."

"What did you say? Don't talk to me like that. You're my girlfriend!"

He leaned in, wrapping his fingers around her red locks, a little too tightly. "That's not the kind of girl you are, Genny O. You're a lady, remember?" he hissed, pulling her hair to remind her who was boss.

"You don't know what kind of girl I am, asshole!" She knew this was not the right thing to say to Martin when he was drunk. But she was tired of this façade. Tired of placating him and tired of sucking his hideous little cock and pretending to like it. She was reaching her breaking point and somehow, he knew it too.

"I can see you're angry that I'm late. Let's forget about it and just have turkey like you said. We can get to the highlight later."

It was clear to Genny that Martin planned on making this the night he took her virginity. As he calmed down, she knew he'd decided that if he wanted his way with her, he'd have to be a little patient. He'd have to have some turkey first and maybe a little pie.

* * *

They sat at the round table across from each other in the middle of the loft, Genny facing the window, Martin facing the kitchen, the installation wall and front door on either side. Because he was late, her plan had been completely thrown off track. She'd have to fake an injury or something, maybe throw up on him. Then when he left, she'd never see him again. She'd not answer his calls. She'd not open the door when he came over. She'd just ignore him completely until he got the message.

Martin finished a second bottle of wine, practically in silence as Genny cut the pumpkin pie.

Suddenly, she saw Thomas's lights go on in studio. Her heart leapt, her face flushed. *What was he doing there after five p.m. on a Thursday? And on Thanksgiving? Oh god, panic. Her lights were on. What if he looked in and saw her here with Martin . . . having a romantic dinner. This would ruin everything. This is not how it was supposed to go.*

She was breathing heavily, fidgeting and distracted. Martin turned around towards the window.

"Who's that? Your neighbor? Do you know that guy?"

She saw that Martin had spilled red wine down the front of his Oxford.

"Um, no." Genny felt a panic attack coming over her.

Would he remember the cater waiter from the party? Would he remember how inquisitive she'd been?

Thomas started fooling around with his new yellow orb.

"Hey, sweetie, want some pie?" she asked, trying to get Martin to face her again.

"Holy shit, what is that idiot doing?" he asked, half yelling.

The orb had fallen off table and was rolling out of control, spitting fire.

"Oh my god, call 911 or something." Martin walked over to the window.

Genny panicked. *Everything is out of synch, everything is going wrong.*

Thomas's clothes caught fire as he tried to catch the orb.

Genny ran over to the big wall opposite the front door of her living room. She grabbed the newest addition from the installation on her wall. As she started towards the front door to save Thomas, Martin's words froze her.

"Wait a minute, that's that goddamn cater waiter!" he screamed. "When did he take that studio? Are you fucking him? Is that why you won't fuck me?"

Genny was confused, her knees became weak. The confrontation scared her and the heavy object in her hands pulled her to the floor.

Martin rushed towards her and grabbed a handful of red hair. As he dragged her over to the window seat, she clutched the object tightly in her hands.

Thomas stops, drops, and rolls.

Genny struggled to break free from Martin's grip.

"Where do you think you're going?" Martin screamed. "Are you gonna save your trashy boyfriend? Maybe he'd like a show instead!"

Martin was out of control, a monster. He was squeezing her arms and forcing her headfirst into

her lovely perch, defiling it with his venomous words.

"I don't even know him," she cried. "What cater waiter?"

"Don't play dumb with me. Do you think I'm stupid? I went to Harvard!"

He pulls her skirt up from behind.

"No panties . . . typical, you fucking slut." His face was bright red, his eyes wet as he pulled out his tiny penis.

"I can't believe you're fucking a waiter *and* an artist!" he cried out.

He smacked her ass hard and she let out an animal-like wail.

Then a rusty, shrill scream choked out of her body. She heard the sound of her voice, loud and powerful. It was as if at that moment she had given birth to a new and transformed version of herself. *Strength*.

"Shut up," Martin ordered. "This is gonna happen rather you like it or not."

Genny would not let him do this. She reached down next to tortured shins and picked up the heavy fire extinguisher she'd been holding. With superwoman force, she flipped around and cracked Martin over the head with it.

He backed up drunk and confused, grabbing his skull.

"What's wrong with you, you crazy bitch? Are you trying to kill me?"

"Get out of my house! I hate you! You're a moron and a pig and I fucking hate you! I've had enough. I'm sick of people running my life. Get out or I swear I'll kill you, you pencil-dicked jerk!" she screamed.

He backed up to the door as she stepped towards him, fire extinguisher in both hands raised over her head.

"You know what? You're not worth it, you god-damn psycho. Don't ever call me again."

"Are you fucking kidding me? Don't worry! Get out!"

Martin scurried down the stairs, reduced to the coward that Genny knew him to be.

"And another thing," he yelled up. "Maybe you wouldn't be such a freak if you got laid. Who ever heard of a thirty-year-old virgin, anyway?" he slurred, trying to redeem himself.

Genny dropped the fire extinguisher, slammed the door, and locked it.

She looked over into Thomas's loft. He was now watching her.

She calmly walked over to the window and opened it.

Thomas opened his window too.

"Are you okay?" he yelled.

"Yeah. Are you okay?" she yelled back.

"Yeah," he said, wiping the sweat off of his brow.

"Hey wait a minute!" He put on his glasses. "You're CVS!" he yelled.

"What?" She then remembered their first exchange. "Oh, yes . . . I guess I am. You wanna come over or something? It's apartment three."

"Yeah, absolutely! I'll be there in a second."

"Bring some music," she added.

Three minutes later, Thomas was standing at her front door with a bright orange CD in his hands.

"Hi," she beamed. "So my real name is Genny O –"

"– Leary," he interrupted. "I saw it on your mailbox. Are you Irish?" he asked.

"Yes, she smiled," looking down, happy to be noticed by him.

"Me too."

"Come in, please. So what did you bring?"

"It's just this CD I've been listening to a lot lately. *Talking Heads: 77.*"

"Jesus Christ!" she managed.

Unbelievable, ironic, perfect, she thought.

"What?"

"Oh, nothing, I just really love that band and that CD's not in my collection."

He walked over to her stereo, popped out Nina Simone, put in *77* in and cued it to "Psycho Killer."

"Thought this might be an appropriate choice," he laughed. "Who was that maniac, anyway?"

"No one. I mean . . . he's gone now. It doesn't matter," she said.

He walked over to her installation wall.

"Wow, That's amazing! Are you prepared or what?"

There were over 300 fire extinguishers on the wall, from floor to ceiling and side to side. All different shapes, sizes and colors, from around the world.

"Yeah well, better safe than sorry," she shrugged, nervously.

"Looks like we're a match made in heaven. I caught myself on fire a few minutes ago," he laughed.

"I noticed." She smiled sweetly, looking down at her hands.

She couldn't believe the object of her desire – the man she'd dreamt of and fantasized about was standing in her apartment in the flesh.

"Um, do you want something to drink?"

"No."

He came closer to stand in front of her. She could smell the smoke on his clothes. He was as handsome as she'd remembered from the party.

She nervously fingered the buttons of her blouse, her Thanksgiving costume. She'd had such different plans for this outfit when she'd chosen it earlier that day.

Thomas's kind face came closer to hers. He gently kissed her on the forehead and she slowly plucked away at the buttons of her top until they were all undone. As it carefully opened up to him, her alabaster breasts fell out from beneath, revealing delicate pink nipples.

"My god, Genny, you are absolutely beautiful . . . your skin," he said, touching her face and chest softly, between her breasts. "It's stunning, so pink, pale, lovely." He couldn't stop himself from speaking this way.

She slid down to the rug onto her knees, hiding her shins.

"No, come here," he said sweetly. Picking her up, he carried her over to the window seat, the spot she'd just been less than an hour ago with Martin.

"Let's make this a place of good memories again."

She wondered if he knew she'd watched him all of these months.

He lifted her into the window. They stood facing to each other, slowly undressing and looking into each other's eyes.

Thomas bent to his knees and cupped her breasts with his strong, soft hands, bringing her nipples to a point. He put his warm mouth on her stomach, kissing,

caressing, and teasing her hips and thighs and then back up to her ribs.

She came down to meet him.

They lay in the window and made love on the brown suede cushion until her fire was extinguished.

The CD tray clicked, rotating to the next selection. It was hers. Talking Heads. "Burning Down the House."

ANAL ANNIE

Genny O stood in the loading zone of the art supply warehouse, waiting for her order and mentally kicking herself for being such a coward. Why had she lacked the courage to approach Dex Roebling? Was it because he was the most breathtakingly gorgeous and sexy man she had ever seen? Or because she was a tongue-tied fool?

They had met a few days ago, so he would have remembered her. Knowing he was a sculptor, she could easily have struck up a conversation about clay or gesso. Instead, she had let the opportunity pass her by.

"Genny!"

Dex's rich baritone penetrated her reverie. He *did* remember her!

"Watch out!!" Dex ran to the edge of the loading dock above her. "Behind you!"

Genny whirled around just in time to see the back of a huge truck bearing down on her in high-speed reverse. She was cornered against the wall of the loading dock!

Dex leapt nimbly off the platform. With cat-like grace, he knocked her down and rolled, covering her with his lean, muscular frame. The truck rumbled over them, its mud flaps slapping their bodies as it thudded into the wall.

Genny trembled in Dex's arms as the thick, greasy drive shaft rotated over their heads. She had been inches from a gruesome death, yet all she could think about was the bronzed, muscular arm across her chest. Scrutinizing the fine, brown hairs reminded her of the microphotography class she had taken at ICP, when she was still searching for a direction to take in photography.

Dex pulled himself up on one elbow to see if Genny was hurt. His keenly trained artist's eye admired her smooth, oval face, straight nose, and full, raspberry lips. He leaned closer to study the hazel flecks in her warm brown eyes. Genny stopped breathing. Was he about to kiss her?

He offered his hand instead.

"Let's get out of here."

Genny slid glumly across the cement, dreading the moment his warm, firm hand would release hers, and their thrilling encounter would come to an end. She was finally in close contact with a man who aroused her – despite her past and the fears that still haunted her – and he was about to dust himself off and leave her forever. She knew she should be grateful: she wasn't dead. But she felt like she might as well be. How could she make him stay?

"Thank you for saving me," she attempted lamely.

She had to come up with a better line than that if she didn't want him walking out of her life!

"My pleasure." He brushed dust from her long, supple arm.

Her flesh tingled where his fingers had stroked. He had touched her – it couldn't be *that* hard to make him stay. Think!

"Can I buy you a cup of coffee?" That was good. Artists love coffee.

Dex smiled regretfully. "I'd love to, but I have an appointment. Maybe some other time." He turned to go. "Take care."

Out of ideas, she watched his back as he walked away. After a few steps, he paused as if considering something, then turned and said, "You could come with me, if you like. It won't take long. We can get coffee afterwards."

He was practically asking her out on a date!

"If you don't have time –"

"No, I do! I have plenty of time!" Genny stammered like a schoolgirl. "I just have to get my paper; that's what I was waiting for. Before you saved me, that is." She smiled at him shyly, but inside she was shrieking with joy. She was about to run errands with Dex Roebling!

She looked around impatiently and saw a stringy-haired sales clerk loping towards her with a bundle under his arm. Dex took it for her, and they headed down the street.

Genny walked on clouds. She was about to spend the afternoon, or at least a part of it, with Dex. She stole sidelong glances at him as they walked, and tried to remember the feel of his body on hers.

"I met you at Mark's studio, right?"

"Yes, but I'm not his assistant any more."

Dex didn't answer; was he already bored with the conversation, or simply too discreet to pry? Whatever the case, Genny wasn't going to let the conversation die.

"I'm working on my own stuff. I have a show coming up."

"Congratulations." He sounded totally sincere. "Which gallery?"

"Longboard." She knew he had never heard of it. "It's out in Bed-Stuy; it's new."

"Excellent. Are you a photographer, too?"

"I do portraits." She indicated the roll under Dex's arm. "I print them on lightweight paper and laminate them like diner placemats. They feel more transient that way, like the people in my pictures." She felt the need to explain, to make Dex understand her art. "I took them on my last trip with Mark. They're people from places like Minnesota who drive south in the winter in motor homes, and how they're never really at home in the desert, even though they live there, sort of."

Genny's voice trailed off. She had been babbling again. But Dex didn't seem to mind. In fact, he seemed interested in what she had to say. Really interested: artist to artist.

"Thus the placemat format?"

Genny was amazed – he really *got* her work!

"What are *you* working on these days?" she asked casually, as if she didn't know.

"See for yourself." They stopped in front of a sleek gallery.

Genny looked up and felt her heart sink. "Oh – Andra Svensson." She should have known.

"Hello, darling," a tall, curvy Amazon cooed from behind a giant black marble desk as they

entered. She looked Dex up and down, ignoring Genny completely.

"Hello, Andra."

Genny was relieved to hear Dex's cool and non-committal tone as he made the introductions.

"Nice to see you," Genny said, just to see if Andra would acknowledge that they knew each other.

Genny marveled at how little Andra had changed since that summer, when she and her teeny tanga bikini had invaded Southampton. On a mission to better her circumstances, Andra had clawed her way through all the rich and willing men she could find. She struck gold right at home with the father of her spoiled charges. Within four months, Dirk Svensson, New York's leading tribal art dealer, had moved his wife and son out, and his former *au pair* in.

"Dex, darling, I need to speak with you about a special project." She steered Dex to her office, away from Genny.

Jealousy gnawed at Genny. Andra might be a feral floozy, but she was still extremely sexy in her skin-tight clothes and chasmic cleavage. She was also smart. She had taste and got what she wanted. That worried Genny most of all, but if Dex and Andra were lovers, there was pitifully little she could do about it.

Genny wandered to the farthest corner of the gallery to escape the shadows behind the frosted glass. She stopped to study a terracotta bas-relief depicting the seven layers of Dante's hell.

"Do you like it?"

Genny looked up, surprised. She had been so immersed in Dex's work she hadn't noticed him approaching.

"It's amazing. I wish I were as dexterous with my hands as you are." She cringed at her own words.

"I guess I should be grateful to my parents for naming me Dexter," he said, his deep blue eyes sparkling as he smiled at her.

"At least they didn't name you Poindexter," she teased, hoping that her smile would bewitch him as much as his did her.

"They saved that for my little brother."

Her eyes widened. "You're kidding!"

"They were pretty strange, all right."

"I'm sorry."

"Don't be – there are worse names than Dexter."

"I meant about your parents. You said they *were* strange. Are they dead??"

"Ten years ago. Pointy and I were in boarding school in New Hampshire when we heard that our father had died. My father's law partner and best friend drove my mother up from New York so she could tell us in person. By the time we got home for summer break he had married her." Dex's voice was bitter.

"You didn't like him?"

"He was a horrible man; he only married my mother because he found out she was sick. She had money, and she had cancer. When she died, he got everything."

"Didn't you contest the will?"

"Of course. But Pointy and I got into a lot of trouble back in junior high school. Just the usual teenage stuff, no mutilated animals or anything, but he knew how to use it against us."

"Dex," Andra called from across the room, "we need to talk about your next show." Her voice was hard and insistent beneath the slutty purr.

Dex and Genny shared a quick look.

"I'm afraid we can't stay," he said.

Genny hardly dared believe her ears: he had said "we," like they were already a couple. Could he possibly be interested in her?

"Darling, you may be a Roebling, but you still need a patron."

So Andra didn't know about Dex's financial misfortunes. Good.

"Squire von Schliessen will be terribly disappointed. And believe me, you don't want that." Andra paused significantly. "We need to lay some groundwork, Dex."

So Andra's swinging days weren't over, either. "Laying groundwork" with von Schliessen had to involve unsavory intimacies.

"I'm sorry, Andra. We'll have to talk about it tomorrow."

Dex touched Genny lightly on the small of her back. His fingertips sent shock waves up and down her spine, and Genny reeled at the newness of it all. She had never been able to respond to a man like this before; did she dare to follow her instincts with Dex? Was it even an option?

Andra gave Dex a cold smile. "If you weren't so talented I'd never forgive you."

"Sorry. I'll call you tomorrow." Dex held open the door, and Genny stepped out, relieved to be away from Andra.

"Wow." Genny was unable to suppress a low whistle.

"She's a piece of work," admitted Dex, "but she's a ferocious dealer. If anyone can put me on the art map, it's Andra."

What good could it do to "warn" him that Andra was a starving man-eater and insatiable swinger? It might even turn him on! Better to leave it alone, especially since Andra had reportedly driven Dirk Svensson to his death. He had lacked his young wife's stamina; the constant orgies and hard-core fantasy parties had been too much for him. That's what Genny's Uncle Otto and his set had gleefully intimated at dinner parties.

And now Andra was a successful gallerist. No tribal stuff for her, though. She had sold off her deceased husband's collection as soon as the last shovelful of dirt was patted over his coffin and had set her sights on "emerging talent," i.e., young men like Dex.

The thought of Dex and Andra thrashing around in bed made Genny's stomach ice over: if Dex could go for a barracuda like that, even in the name of art, it meant that he wasn't the man she thought he was.

But Genny refused to believe he was just another self-serving sculptor. He couldn't be, not when he affected her this way, not after all these years of waiting. Her body felt vibrant and alive, and her loins were awakening and growling for attention. She could feel herself responding to Dex, could feel herself blooming, opening, yearning.

Suddenly, Genny knew: Andra or no Andra, she had to have him. Her instincts told her that Dex was the one, that he had to be the first, that she no longer had to be afraid.

But what if he didn't feel the same way?

Dex stopped in front of a dilapidated industrial building and fished out his keys.

"How about coffee at my place? There aren't any decent coffee shops around here."

Genny's heart was beating like a hummingbird's as they climbed several flights of sloping stairs, but it was from excitement, not shortness of breath. They entered a spacious loft, empty except for a table and chairs, a bed, and a large, mysterious mound under a thick sheet of plastic.

"Espresso?"

"Macchiato, please," she said, hoping he wasn't one of those soymilk types.

Genny looked around while Dex ground the beans.

"Have you lived here long?"

She didn't dare ask if he lived alone.

"I moved here when the neighborhood wasn't zoned for residential use. I camped out for a few years; I even had blackout curtains. But now I'm totally legal." He smiled at her as he screwed shut the espresso pot. "Check out the view."

Genny crossed to the windows, trying not to look at the hastily made bed. At least he was neat. Or had Andra done that? No, Genny decided, Andra would never bother to make a bed.

She forgot about Andra, and was lost in admiring the view when Dex handed her a cup of black coffee with three foamy spots of hot milk in it.

"Not bad, huh? You can see all the bridges on a clear day."

They stood side by side, then Dex asked, "Want to see something cool?" He led her by the hand across the

room towards the plastic-covered mound on the floor. Genny could hardly breathe – her hand felt so good in his. He lifted the tarpaulin, revealing a mass of moist, brown clay.

"I thought you might be interested in this, since you were just in the southwest. I get it in New Mexico from an isolated Indian tribe." He picked up a small handful. " It has a finer texture than ordinary clay."

Genny crouched down cautiously beside him. Thanks to Mark, she was wary of anything having to do with Native American spirituality and enlightenment – after all, it had only taken him five minutes of gibberish about some old witch doctor to get her to take that peyote.

Squatting by the clay, Genny hoped that Dex wouldn't ask her to pose for him. After that episode at the hot springs, she had promised herself she would never expose herself again, no matter how talented or important the artist.

But Dex didn't seem to want Genny to do anything more than feel his clay. She reached out tentatively and let him smear a small bit of the clay onto her fingers.

"Try it like this." He moved his thumb back and forth over her trembling fingers.

Genny's breath came in shallow gasps as the powerful ache in her groin grew, threatening to overwhelm her. She looked up at Dex, inviting him to see her lust. Before either of them knew it they were kissing.

Tenderness flared into passion. They caressed wildly, smearing each other's clothes and skin with the sticky, slippery clay. Genny stroked his neck, his powerful, broad shoulders, his sinewy arms – she touched

everything she had admired with her eyes. Dex groaned as he caressed her smooth, warm back, pressing her closer to him. She savored the feel of his lips on hers as they met again and again, lingering longer and longer.

She writhed against the mound of clay, literally throbbing with desire. Dex slowly unbuttoned her shirt and gazed at her honey-colored breasts. He touched her pale pink nipples ever so lightly, and Genny gasped as they hardened.

Not thinking, just doing, she helped Dex pull off his T-shirt. His chest was smooth, his skin a deep golden tan. She raked her fingers through the clay and used it to paint patterns on his chest, across the pectoral muscles, and around the etched contours of his abdominal muscles.

She reached to unbutton his pants, but he moved back and stood up. He lifted her to her feet, reached behind her waist, unzipped her mini skirt and let it flutter to the ground. He pulled her lacy white panties down to the floor. Genny stepped out of them shakily and stood trembling.

"God, you're beautiful," he whispered as his eyes devoured her body.

Genny reached for his pants. She wanted to see all of him, the way he was seeing her.

"Wait," he said, gripping her and easing her down into a sitting position against the wet mound of clay.

Genny let Dex lift and part her knees and was aroused by the quick intake of his breath as her swollen womanhood spread for him.

He knelt down and lowered his head between her thighs. Genny was transported into a realm of delight

unlike any she had ever known. Dex's tongue and fingers made her squirm helplessly with exquisite pleasure. Within moments, she felt the heat explode from the center of her womanhood and spread throughout her body in spasms of ecstasy.

After the shockwaves had subsided, Dex began again. Genny moaned, certain she could bear no more. But she was quickly overcome by an orgasm of even greater duration and intensity than the first.

Unable to contain himself, Dex sat back to open his pants. Genny helped him, wanting him as she had never wanted a man before, mindless of the fear that had kept her from doing this with anyone else.

Genny paused before extracting his manhood. After this there could be no turning back. She was about to enter the sacred realm of full womanhood, and she wanted to savor every moment.

She took a deep breath, reached inside his boxer briefs and felt his thick, hot maleness straining to be free of this confinement in exchange for another, sweeter place.

She pulled his pants off and Dex mounted her, his turgid maleness poised at the portal of her maidenhead. She gripped his hips and held him above her, the velvety head of his manhood just touching, quivering as it waited to enter.

She closed her eyes and tried to relax. Suddenly, her Uncle Otto loomed above her, his sweaty face leering, his breath exploding over her young face in quick, garlicky gusts as he smeared his flabby impotence against her pajama bottoms.

Genny's muscles clenched involuntarily, keeping Dex's maleness at bay.

"What's wrong?"

It was time to conquer this demon once and for all. She didn't answer, just opened her eyes. Uncle Otto was gone. There was only Dex now, his eyes aglow with molten desire, and concern.

Genny couldn't let him stop now. She relaxed her muscles completely and pulled him slowly into her, catching her breath sharply as he entered.

"Genny," Dex whispered, "are you a virgin?"

She spread her legs wider, allowing his manhood to penetrate more deeply.

"Not any more."

She thrust her hips upwards to take him in further and prove she wanted him. She squeezed her inner muscles to welcome her first visitor. Dex used his manhood to stroke her slowly and gently. Gradually increasing their tempo, they met again and again, mashing and writhing in the clay, squishing it beneath and between them until it was part of their living, breathing sculpture.

Genny became a vessel of pure pleasure, her mundane self left far, far behind. She felt her entire body tingling and heard her cries as if from a great distance. Yet she was completely there with Dex, stroke for stroke, thrust for thrust, until the wave they were riding exploded into millions of shimmering droplets as it pounded onto the shore of their mutual passion.

They lay together a long time, spent, not wanting the feeling to end. Finally Dex suggested a long, hot shower. He peeled Genny off the clay and carefully replaced the tarpaulin.

"I can't afford to let it dry out," he said. "Besides," he grinned, "I don't want to lose our prints."

Dex's shower was an open stall with a giant show-erhead that operated by pulling a chain. They took turns washing each other with a big, soft sponge. Dex crouched at Genny's side, rubbing her legs with large, circular strokes, working his way steadily to her buttocks.

"Oh my god! I should have known it was you!" He stared at four little freckles on her bottom. They were the same size, evenly spaced in a line across her right cheek.

"What is it?" Genny asked, trying to hide her rising panic.

"I know this constellation." He smiled up at her.

She jerked away from him.

"That's impossible!!"

"Mark showed me the pictures."

Genny dashed across the bathroom, grabbed the nearest towel, and wrapped it protectively around her naked, wet body.

"He promised never to show them to anybody!"

Dex wrapped himself in another towel and went to her.

"He's putting them in a show, Genny."

Genny buried her head in her hands. She would never have let Mark take those pictures if she hadn't been tripping on peyote. They had been soaking in some natural hot springs after finishing the assignment for *National Anthropologic* when the drug had taken effect. Mark had insisted on capturing the synergy of man and nature, "man" being her naked bottom.

She had begged Mark for the negatives. But he had refused to give them to her, had even tried to make her feel silly for being so square.

"I can't believe he showed them to you!!"

"I'm sure your secret is safe; he didn't say who it was. Just some girl named 'Anal Annie' that he had met in a diner."

"Anal Annie? Diner?!" So Mark had not only given her a disgusting nickname which implied that she had given him anal favors, he had also made a mockery of her work!

Genny's head was spinning. It was bad enough that Mark was trying to destroy her reputation. But it was far, far worse that she had given herself to the man she thought was her soul mate. He wasn't noble and true at all! He was in cahoots with the peyote pusher who was about to drag her through the mud of shame! They were probably planning to give the pictures to Andra Svensson so the three of them, and their circle of anal swingers, could have a laugh at her expense.

"They're beautiful pictures; they're nothing to be ashamed of."

Genny twisted herself free of his Judas grip.

"You're not the one being bandied about as Anal Annie!"

"That was just guy talk. He won't tell anyone."

"What makes you so sure? Mark promised not to show them, and now he's putting together an exhibition!"

"Those pictures are a real breakthrough for him, a chance to get beyond commercial photography."

Genny shook her head and turned away.

"Look," he tried again, "I understand why you're angry. Mark should have had the honesty and integrity to tell you about this show."

"There shouldn't *be* a show," she said through gritted teeth.

"Genny – we're artists. When we create work that's this important, we can't keep it hidden."

"But it's *my* butt!!"

Genny suddenly remembered the imprint of her butt in the wet clay. Dex wasn't going to include it in *his* show, she'd see to that! She ran out of the bathroom and ripped the plastic cover off of the clay. She jumped on the smeared imprint of her backside with both feet and dug her heels in, destroying the evidence of her misguided passion.

"I'm not letting anyone else exploit my butt!"

Dex knew he had to regain Genny's trust, and fast. He took her face gently in his hands and made her look at him.

"Mark won't tell anyone your secret. I'll make sure of it."

Genny stared at Dex through flinty eyes, doubting she could trust him. After all, what did she really know about him? What assurance did she have that he respected her enough to keep her secret? In his eyes, she was probably no better than a common tramp. She had just slept with him, a virtual stranger. He'd gotten what he wanted from her. No doubt he was anxious for her to get out of there and out of his life. How could she stop him from boasting to all his artist friends that he had done it with Anal Annie?

Dex squared his shoulders with resolve.

"There's something I have to show you." He reached out his hand, but Genny refused to take it. He let it drop and walked across the room to a heavy metal door she hadn't noticed earlier.

He turned back to her. "Please. It's important."

Genny gazed at him in his towel and felt her loins begin to burn again. Deeply, helplessly ashamed, she realized that she was no longer the Genny she had been only hours ago. She was in the full bloom of womanhood now, at the mercy of her erotic needs. She was utterly powerless to deny him anything he asked. Her dignity, her privacy, her values were meaningless. She had never felt so vulnerable. Nor so completely alive. Slowly, she crossed the room to go wherever Dex wanted her to go, to see whatever he wanted her to see.

"Nobody knows about this. Nobody but you." Opening the heavy metal door, he stepped into a dark room and flicked on the overhead lights. Inside, next to a tabletop cluttered with painting supplies, Genny saw a pastoral canvas on an easel. She stepped in to look more closely, then turned to Dex.

"Is . . . is this your painting?" The disbelief was evident in her voice.

"No – it's a Michael Kincaid. I do custom highlights under an assumed name. I have the printed canvases delivered to this studio. It has a separate address and street entrance."

He watched Genny carefully as her mind whirled with the gravity of his confession. As far as the art world was concerned, this was far worse than posing for artistic nudes. Besides, Mark could never prove that Genny had done anything with him, anal or otherwise. But this was different. Dex was going out on a limb to prove to her that he could be trusted.

"Nobody knows about this. Absolutely no one but you."

Genny glanced at the cozy cottage nestled against a background of gently rolling hills. It was in soft pastels except for the hand-painted yellow highlights around the cottage windows that gave off a warm, welcoming glow.

She looked at Dex, then back at the painting, then back at him.

"What can I tell you – I need the money." Dex grinned, the corners of his eyes crinkling irresistibly.

Unable to help herself, Genny smiled back at him. Dex pulled her close and kissed her lightly on the forehead.

"Now we both have a deep, dark secret. You keep mine, and I'll see to it that Mark keeps yours."

How foolish she was not to have trusted him! She ran her hand through his thick chestnut hair and gazed at him with wonder.

"I'm glad I almost got run over by that truck. Otherwise this could never have happened."

Dex looked down at her with the same serious expression she had seen on his face when they were making love.

"It would have happened. Maybe not today, but it would have happened."

They stared into each other's eyes, then melted together in a long, slow kiss, the cottage windows glowing behind them in the light of the setting sun.

BANANA DREAM

Traffic was busy for a Wednesday night. By the time she parked it was well past eight.

Too late to go out, too early to stay in.

Disruptions presented problems for Genny. She liked her routines; getting home late forced her to improvise.

Dinner was always a problem.

She decided on a pasta sauce, the unfashionable kind, the kind her father used to make – heavy on the beef, lots of tomatoes. While cooking she would listen to the radio, then eat at ten. A hot bath and an early night. That was her plan.

When she left for college, her mother gave her this advice: "Stock your freezer full of meat and keep at least three cans of tomatoes in the pantry. Buy your produce every day – bread every other day."

Although she ate out most nights, Genny would often stop at Ali's after work, a meal plan in mind. On Sundays she would take the rotten vegetables from her refrigerator and double-bag them, dropping them

down the garbage chute. Her freezer was stuffed with half-pound bricks of ground round; her cupboard – in Jim's words – "a Warhol of canned tomatoes."

It was at Ali's that she loaded her basket with crimini mushrooms, a celery, two green peppers, and a white onion. She deposited the contents on the counter – when something caught her eye.

Bananas.

Genny hated bananas. She found them too sweet, their texture too mushy. But underneath the fluorescents, the bananas looked powerful, alive. One stood out – probably the same one Dole was so enamored with when issuing stickers.

Imagine what that might look like under my halogens? she thought. Might Jim see the same thing as me?

Something about a banana in its skin.

She tore it from the bunch and placed it on the counter.

Behind the counter stood Achmed, Ali's eldest son. He worked the night shift – eight p.m. to eight a.m. She didn't have to look at him to know he was staring at her.

To prompt him, she picked up the banana and put it on the weigh scale.

But Achmed didn't budge. She imagined his mouth curling, an eyebrow cocked to the rafters.

"Are you certain that's the one you want?" he asked.

Genny resented the inference. Achmed was always making innuendos. If she didn't know him – if he wasn't such a creep! – she might think him good-looking.

"No," she said, "I would prefer something larger but –"

"*But!*" Achmed pounced on the hesitation. "But *what?*"

Genny froze. She had no idea why she said that. Her mother always told her to turn the other cheek when confronted with aggression.

She could feel his eyes all over her. If they were snakes, she thought, they would be crawling under clothes by now.

Achmed checked the weigh scale. He peeled the sticker from the banana, then checked again. "Ah, it seems your inadequate banana comes to sixty-nine cents. Sixty-nine – an auspicious number where I come from. Did you know. . . ."

Genny could feel her cheeks burn. Thankfully, an older woman was approaching. An Arab woman, like Achmed. Not that the woman – nor anyone – could stop Achmed's rising laugh. Like a machine-gun attack, Genny thought, as she threw down a ten and scooped up her produce, leaving her change behind.

She could hear him on the other side of the street, over traffic, his laughter ricocheting off the buildings.

It was always like that when Achmed worked – his jokes, his laughter, whenever she got home late.

The radio station Genny listened to played Soft Rock Classics, but after the first two bars of "Easy" she fiddled the dial, stumbling on a multicultural station at the end of the FM band. A regular feature devoted to English translations of world literature. Tonight's program: part 43 of *The Thousand and One Nights.*

Something about the host's voice – its warm tone, its English accent. She found it comforting; the voice of someone who had left his war-torn country for a better education. Not like those radicals on TV; more like

Ali, she thought – a man out to improve himself. A gentleman.

And so she stayed with the program, thinking the tales might give her insight into Achmed's annoying behavior.

Genny prepped the vegetables as Sinbad the Sailor set out on his last three adventures.

No sooner had her plate touched the placemat when the phone rang. "Jim!" she thought, lunging for her cell. Only it wasn't Jim – it was a client, Mr Herzog. He was calling to say his check might bounce, and could he drop by with cash instead.

Genny's employer had a policy about home visits. Although she knew it might be the company's only chance to get paid, she declined his offer. He appealed. But her mind was made up: she would hear him out, but it wasn't worth risking her job over.

When she returned the narrator had begun a new tale. (She would never know what became of Sinbad, nor those he set out with.) But this new tale was just as engrossing: the story of a widowed merchant, Abu Hasan, who was forced to leave Yemen because of a terrible accident. From the narrator's tone, Genny inferred the accident was trivial, that Abu was making too much of it.

Like Jim, she thought. Poor Jim, who had to leave Minnesota because people thought his photographs pornographic. Not that that was his intention. Jim's photos were beautiful – as beautiful as Mapplethorpe's, his gallerist once told her.

Although she had never seen Jim's early work – nor anything by Mapplethorpe, for that matter – she knew both started out with nudes before turning to

flowers. She also knew that Mapplethorpe, no matter how pornographic his nudes were said to be, was a name to be reckoned with. Which is what Jim wanted – to be reckoned with. What artist wouldn't want that? It's what you want when you want to be an artist. And besides, how could this Mapplethorpe get away with nudes, but not Jim?

As the story continued, her image of the merchant became indistinguishable from Jim's.

Now disguised as a dervish, Jim returned to Duluth.

"He went round the outskirts of town, and, as he sat down to rest at the door of a [house], he heard a voice of a young girl within, saying: 'Please, mother, what day was I born on? One of my friends wants to tell my fortune.'

'My daughter,' replied the woman solemnly, 'you were born on the night of Abu Hasan's fart.'

When he heard these words, he got up and fled. '[Jim],' he said to himself, 'the day of your fart has become a date which will surely be remembered till the end of time.'

He traveled on until he was back in [New York], where he remained in exile until his death. May [God] have mercy upon your soul."

It was 3:14 a.m. the last time Genny looked at her clock. Her tummy was growling – she was hungry – but the thought of eating repulsed her. "The Historic Fart" had made her nauseous, and after vomiting she skipped her bath and took a Tylenol. She considered taking another, but as Tylenol made her constipated, she rolled over instead, doing what she could to let the world go.

But the story wasn't the only thing bothering her.

It had been ages since Jim last called. She knew he was in the darkroom, and that once he finished, he would phone. Usually this meant the third day.

Today – or yesterday – was that day.

At 3:17 a.m. she gave up. Remembering the Ativan her boss once gave her (a red-eye flight, canceled in the wake of "recent events"), she went to the bathroom and dug through her toiletry case. She was about to put the pill under her tongue when she thought she should at least pad her stomach first. She had never taken an Ativan before; she thought it might upset her.

But there was nothing in the house. At one point she considered a spoonful of pasta sauce, but abandoned the idea, as the taste would only remind her of "The Historic Fart."

She craved something fresh, something healthy.

As much as she hated them, the only thing available was the banana.

Serves Jim right, she thought, as she peeled off the skin, devouring the banana in four angry bites.

Genny never recalled her dreams – but on this night, after the Ativan, she found herself flying.

She was flying over Minnesota, following the highway to Jim's hometown. Below her, the many shades of green and bright blue lakes that made up the landscape.

At one point she wondered what was propelling her. But when she checked herself, it was just her and her nightie – no jet-packs, no magic carpets. She was traveling under her own power, guided by a force beyond her control.

The next thing she knew she was lying on her stomach, in a forest. Light filtered in, birds chirped.

Beside her, a small wicker basket; inside it, an assortment of mushrooms. She picked up the basket and walked towards a cluster of chanterelles. When she picked all the chantrelles she found another cluster. Then another. But the basket never got more than three-quarters full.

Under normal dream-time conditions, this would have caused Genny anxiety. But not in this dream. In this dream she was glad to be out of the city.

Eventually she came upon a clearing, in the middle of which stood a circle of colorful tents. But these were not circus tents, nor were the people milling around them circus performers.

Bedouins, she said to herself. Nomads. But what are they doing in Minnesota?

The incongruity frightened her; she turned to run – but standing before her were three women, each of them veiled. One in red, one in yellow, one in blue. The women seemed anxious. Again, as with the mushrooms, this would have caused Genny anxiety too. But not in this dream. In this dream she was convinced the women had her best interests at heart. As long as she obeyed them, she would feel safe.

The woman in blue took her by the arm and lead her towards a bright purple tent; a massive structure, supported by many poles.

The woman in yellow ran ahead, pulling back the door flap.

Genny stepped inside. She could not believe her eyes.

The tent was filled with giant pillows and great swaths of fabric. There were bronze statues, paintings hung from the ceiling, every few feet a magnificent bowl of fruit. In the center was a fountain, its spout frozen;

but not as ice – more like a video set on "pause." Everything was still. It was just the four of them.

She was lead to the fountain, where she was given a small tin cup. One of the women told her to drink from it. Genny knelt down and filled the cup, lifting it to her mouth.

As soon as the water touched her lips she felt a warm breeze.

Genny noticed her breasts were exposed – indeed, she was naked all over! Startled, she stood up, but the women comforted her, returned her to her knees, urging her to drink more.

Another sip, and another breeze – this one even warmer.

It's okay to be like this, Genny said to herself, and the woman in red nodded.

She took a third sip, after which she became aware of other bodies, men and woman, climbing out from under the pillows. They were naked too. Some of them embraced, while others were more adventurous. One woman, no more than six feet away, was on her knees, sucking on an impossibly thick penis. Genny couldn't take her eyes off her. Although her mouth was engaged, Genny could tell from her eyes that she was smiling.

Genny could feel something touch her back – a pair of hands, rubbing the muscles at her neck, the ones she reached for after work. Intelligent hands, she thought, hands that knew what they were doing. She encouraged them, letting her head drop, then her shoulders. Soon she was leaning on her elbows, the cool fountain air stiffening her nipples. She wanted to know who was doing this, who the hands

belonged to, but was afraid to ask. Afraid they might stop.

So she said nothing, dropping even further, until her forehead touched the ground, her buttocks in the air.

From this position Genny could look backwards, between her breasts – a pair of testicles, hanging there, as if her own. A man's hands, she thought, as she reached underneath, pulling his testicles towards her.

The man responded, pressing himself against her crack, filling it, then moving it up and down, the head of his cock burning hot against her anus. She could feel his testicles retract, the scrotum hardening. She arched her back until she could feel the scrotum brushing over her clitoris. When she clenched her ass, the penis pushed harder – hard enough that she could record every inch of it, the information travelling through her body, appearing as an image in her brain.

Long and thick. Uncircumcised. Huge.

Genny knew she was dreaming, and that whatever happened wouldn't count. Her impulse was to extract as much pleasure as possible. The head of the penis was now stubbing against her vagina, on the verge of entering. But she was ready. She had never been so ready. Her vagina was sopping wet.

No sooner had the thought crossed her mind when the penis entered, filling her perfectly in five slow strokes; only to stop, as if waiting for further instructions. She could feel one hand over her breasts, the other on her clitoris, applying pressure, though never dwelling. She leaned forward and the penis withdrew; she leaned back and it filled her once more.

This went on for some time.

Her pleasure gave her the distance she needed to look back on her past. She recalled not only Jim but those who came before him, each of whom she gave a little more to. The college boyfriend, whom she blew; the high school steady, whom she masturbated; the boy in grade seven, who she let touch her bum; and her biggest secret – the one that didn't count – the babysitter, who, during the summer she turned thirteen, entered her room one morning and pushed himself inside her.

His was the biggest.

Until now.

Because whoever was behind her erasing all that. This was the one she'd been waiting for, the one she needed to give her the distance.

Her thoughts wandered. She was thinking of the woman with the penis in her mouth, how happy she looked. She wanted some of that for herself.

As before, as soon as the thought crossed her mind. . . .

Genny was now on her side, a man's tongue brushing over her clitoris, his fingers inside her while she gathered up his testicles and sucked them into her mouth. She could feel his penis stiffening against her cheek. When it was rock hard she pulled down the foreskin and wrapped her lips over the smooth purple knob, his pubic hair smelling like cinnamon.

Another body had joined them. This one from behind, also pressing. Once again she could feel herself being entered – only this time it wasn't her vagina, but her anus. His was big too – though in a different way. Curved and pointy. It hurt. But not too much.

Whatever was behind it – like the hands that massaged her neck – had respect, intelligence. She was impressed with its patience; it knew when to stop; it had intuition. Indeed, it was this intuition, and the trust she had in it, that made the dialogue over her pain the basis of her orgasm.

When she came, she came in waves – the experience having more in common with something else from her past: when she was nine, in Hawaii, lying at the water's edge, her legs open to the rise and fall of the incoming tide. It had nothing to do with sex – yet it was, until now, the best she'd ever had.

Genny felt a thud. Then another. The earth was moving. People were getting to their feet, running. A series of explosions, each one closer than the one that came before. She looked up – the tent was in flames! Whoever she was lying with had vanished. But she could still feel something inside her. She reached around and withdrew not a penis but a banana. Someone grabbed it from her, broke off the stem, and threw it at the advancing army.

It was Achmed.

She awoke.

For the first time in her life she had overslept her alarm. Her morning routine never took less than an hour, but today she was out the door in twenty minutes.

She turned up the street, towards her car.

A voice from behind called out.

It was Jim.

Only it wasn't the same Jim. Not the Jim she pined for. Same shape, same color, same movements – but not the same Jim.

He jogged towards her, his little boy grin looking more like Bell's Palsy than guilt.

"Yeah, sorry I didn't phone," he began, "but I hit pay dirt in the darkroom and, well, you won't believe these prints."

She stared at him. She didn't know what to say.

"You understand," he said sheepishly, leaning in for a kiss.

She jumped back. "I have to go, I'm late."

"Genny, wait!"

He chased after her, but she didn't stop. Only when he grabbed at her skirt did she turn around, holding her briefcase like a shield. She was angry – and he was laughing.

Laughing!

What? she kept thinking. Why is he laughing like that?

Out of the corner of her eye she could see Ali, across the street, holding his broom. His posture told her she could count on him if necessary.

She shook her head; it was okay, she could handle it.

"There's something stuck to your ass," said Jim, still laughing.

Genny turned around, looked behind her. In doing so she took a step, then another, like dog chasing its tail.

For a second she thought she might out of control.

"Here –" said Jim, removing the sticker, holding it up for her inspection.

"Dole?" she said incredulously. "*Dole?*"

Then it all came rushing back.

O in rOme

"O . . . O . . . o o oooooowwwww!" Genny gasped, her whole body shuddering. She pressed her legs hard together, intensifying the sweet tremors rippling through her like an electric current. They had begun to slip away almost as quickly as they came. Rolling onto her back, Genny pulled her cotton nightie down and pulled the sheets up around her neck in what was proving to be a rather futile attempt at putting her bed back in sleeping order. No matter. As she mused in harmless embarrassment at the vigorous abandon with which she had enjoyed herself, she felt the faint pulse of an aftershock like a delicate but effective promise of future pleasures. Her fingers performed their nightly ritual, softly tracing the outline of the embroidered strawberries on her linen pillowcase and, with a big satisfied smile, she relaxed in comfort, giving way to the gentle welcome calm of drifting off to sleep. Soon she would know what *it* feels like for *real*.

Genny had been on plenty of dates in her twenty-two years but she always managed to keep her men at

a friendly distance. Maybe it was her cool self-assurance and strong opinions that discouraged them from moving in closer, or perhaps it was that she always seemed preoccupied. As an ambitious young artist, she was indeed preoccupied. She routinely spent long stretches of time isolated in her small apartment reading thin volumes of poetry and thick volumes of theory, shooting still lifes with her large-format camera, or making small paintings of her creased bed linens and other intimate household items. The truth is that Genny was never sexually interested in the cute young artist wannabes who asked her out. They were always amusing, but they could never compete with the memory of him. He was her main preoccupation and she didn't dare to tell even her closest friends. It had been difficult keeping her love for him a secret. If she started to tell her friends about him, she would have to tell them everything, and she could never do that.

She was leaving for Italy in the morning to be in a large group show – her first European exhibition. All the letters he had ever sent had been excavated from their private hiding spot, the front of each envelope copied into a series of small drawings. Names, addresses, dates, and stamps were carefully represented in colored inks. Showing them was innocent enough and she knew the effect it would produce on him. She would show the world the outsides but only he would know the insides. He would be at the opening. She had made sure of that.

Excited, unable to sleep, Genny woke up hours earlier than she needed to. She took a long bath scented with jasmine oil to calm her nerves. She was overwhelmed by the fact that she had finally summoned

the courage to face him. It was a huge risk that would forever change them both. She had dreamt of going to him every single day since they parted but he had strictly forbidden her to come too early . . . too young. The invitation to exhibit had provided her with a reason to go, a means of meeting him as an equal, as a grown woman, as a successful artist. The bathroom window was wide open and the morning breeze felt sharp against her shiny, soft, wet skin. She loved how the cold made her nipples feel like little rocks and she could not resist sliding her hands over her pungent oily body. Imagining his expression when they would finally meet face to face, she pulled the plug and opened her legs wide to more fully enjoy the sensations of the cool air.

Genny had no fear of flying but rather a fear of air-ports. Until she was seated on the plane with her belongings safely stowed in the compartment above, she would constantly worry about things like missing the flight, losing her boarding pass, or forgetting her passport. Her excitement about her upcoming en-counter enabled her to get to the airport, find her check-in counter, get to her departure gate and board the plane without breaking a sweat. In her window seat waiting for take-off, she was oblivious to her fellow travelers who seemed to be nothing more than a vague blur in the periphery of her vision. Her thoughts turned to her aunt who was her best friend and to whom Genny owed everything.

Aunt Gina was beautiful and powerful. She was an internationally famous artist of unparalleled proportion, a bona fide art star, which was no small feat for a woman in a man's world. Genny's admiration for Gina

knew no bounds and it seemed that the feeling had always been mutual.

Over the years they had spent many hours in heated debate about art and history and even more hours laughing about nothing at all. Genny knew that most of her success so far was due to Gina's connections and that this exhibition was just another item on a long list of gifts from her aunt. It pained Genny to keep secrets from Gina, to whom she could normally tell anything. But how could she tell her? It was, after all, Gina who first introduced them. At the time Genny had strongly suspected that there was something going on between them but that was true of her aunt with many handsome men. She had almost dared, on occasion, to ask but was afraid her interest would somehow give her away or perhaps she was afraid, given her feelings for him, what the answer might be. It would seem a natural enough question. He was the best-looking man she had ever seen and a brilliant artist whose intellect alone would have captivated Gina. The thought of him brought her back to her bathtub. She could still faintly smell the jasmine on her skin.

They had met when she was a barely a teen on holiday in Rome with her aunt. He was unshaven and wearing only a weird but sexy bohemian striped kimono. His long brown hair framed his large brown eyes perfectly. Aunt Gina was helping him sort out some papers and Genny couldn't take her eyes off him. His inviting full lips kindly offered her an espresso, which made her feel very grown up. She took it black, impressing them both, as even Aunt Gina used a cube of sugar in hers. Genny reclined in a big comfortable leather chair by the patio door of his studio.

Outside was an overcast and stunning panoramic view of Rome; inside was a large bright room, empty except for carefully organized piles of paper on a shiny wooden floor. With her back to Rome, she watched them work as she drank her bitter coffee. She knew then that she too was going to be an artist. She had kept her eyes on him the entire time, watching him walk around the room conversing gently in English and Italian about visiting New York, about other European artists. He ran his hands through his hair, then rested one on his chin surveying the small paper columns that somehow made up an artwork. He was deep in thought and oblivious to her constant stare. From time to time he would pick up one of the papers and point something out, telling them a story about it or directing a question to Gina.

Although Gina married an American museum director shortly after this visit, they seemed to really enjoy each other's company and seemed to be making progress in their work. Occasionally he would look up at Genny and smile apologetically, concerned perhaps that it might be boring for her – as if she cared about exploring Rome on her holiday. He promised to make it up to her by personally taking her to see the sights the following day. Aunt Gina suggested they go to the Spanish Steps. Unfortunately she would be unable to join them because her Roman dealer had plans to show her off to potential patrons.

She awoke with a start. She was hot and sweaty. Her leg had cramped up and the pain in her ears was unbearable. The plane was descending for landing. She fumbled about in the seat pocket in front looking for chewing gum. How long had she been sleeping?

She remembered the reheated-in-the-microwave meal with glasses of red wine followed by scotch. She remembered talking to the middle-aged man sitting next to her who was now comfortably reading and completely unaware of the pounding in her head. He was English, a salesman or a businessman. He had seemed pleasant enough and very polite. When asked the inevitable question about the reason for her trip, she simply told him she was going on vacation.

She hated telling strangers that she was an artist. They either were way too impressed, or skeptical and suspicious, or they would goad her for a convincing explanation of why something nobody cared about was art. She tried to imagine his polite reaction if she had told him the real reason she was going to Italy. She rhythmically chewed her gum determined to ease the pressure and she wished desperately for cold water and aspirin.

Genny's desire for him seemed to at least double as soon as she stepped foot in Rome. As she made her way out of the baggage claim she fantasized that he would be greeting her in a movie-like embrace. But she had purposely given him no information about her itinerary and only teased him with a strong hint about the opening sent with her last group of "special" photographs – a hint he could not misinterpret. So instead she was met at the airport by Rosa, who was clearly recognizable as an employee of the gallery by the manner in which she was waving Genny's last exhibition catalogue around.

Rosa had a mass of curly long dark hair worn loose, her curvy Italian body barely contained by a tight white top, matching skirt, and red stilettos. She

punctuated her outfit by tying a silk scarf, boasting a bold geometric print, loosely around her long neck, the two halves draped down her front, providing a perfect frame for her tempting cleavage. Her sexy style clashed harshly with her slightly run-down but cute little Fiat. As they sped toward her hotel, Genny felt as if she were in another universe – a universe where she appeared very dull in her standard-artist black ensemble and comfortable shoes, where the sky seemed huge and she felt very small. Her ears were still plugged from the plane, making the roar of the car and the purr of Rosa's voice seem alienating and distant. She felt a glimmer of fear about her plan. She wished she had arranged for him to meet her instead of trying to be clever. She considered asking Rosa to turn the car around. Instead she wondered if Rosa had devised a special outfit for picking up artists or if she always looked so fabulous. Genny took note of the ridiculous nature of her thoughts and stopped herself from going any further with it. She took a long deep breath and told herself that Rosa's fashion statement was not designed to specifically intimidate her. She felt her bad mood begin to lift and resolved to try to like Rosa. She discreetly unbuttoned her own cotton shirt a bit to get in the Italian spirit and started paying better attention to her driver, who seemed happy to talk about herself as long as Genny seemed happy to listen.

Rosa was a student volunteer at the gallery who was studying to be a curator. She was amusing and talked a lot in perfect English pointing out architecture and landmarks as if Genny had never been to Rome, but most importantly, she miraculously had *dell'aspirina*.

Genny finally felt at ease for the first time since the morning and took this newfound ease as a good sign. Just when she was sure everything would work out as planned, something extraordinary happened. Rosa began to speak casually about him!

She knew him! She knew him well! Were they lovers? Genny's mind began to race. She had never met anyone, besides her aunt, who knew him – and Rosa was so *irresistible*! Back in the airport parkade Genny had admired the faint red outline of Rosa's tiny panties through her thin white skirt. They *were* lovers! Her tears welled up as she imagined them rolling around on satin sheets. He was biting the buttons off Rosa's white blouse revealing more and more of her soft flesh, she was arching her back and reaching for his – Genny blocked out what came next in her vision. She looked at Rosa with tears streaming down her face, she knew she could not compete. Was it really only a game to him? Had he been leading her astray all these years with his letters?

Rosa pulled over on the side of the road and looked back at Genny in shock. Her big brown eyes were full of concern. She placed her hand on Genny's shoulder, evidently having no idea what brought on Genny's distress. That was it, thought Genny, his letters. Her drawings had his name on them. Rosa was simply making conversation by trying to talk to her about her work. Genny felt very low. She took the tissue Rosa was kindly offering her and blew her nose long and loud to buy time. She quickly made up some lame excuses about her headache, her long flight, and pre-exhibition stress. She knew it was hardly a convincing explanation, but it was enough to get the Fiat back

on the road. They traveled the rest of the journey in silence.

Alone in her room, she collapsed on the bed. Ashamed and embarrassed by her behavior with Rosa, she was determined to put the whole thing out of her head. Despite total exhaustion, she was unable to sleep. The picture she had painted of the lovers would not leave her head. What if her suspicions weren't wrong?

She longed for him. To comfort herself, she thought back to the day she had spent with him savoring every glorious detail. She remembered her excitement as she got ready for her date. She was glad she had reached puberty early because at the age of twelve she had already developed a nice shape. She examined all the clothes she had packed and in the end "borrowed" a sheer halter mini-dress from her aunt's closet. It was an evening outfit that was much too old for her but at the time she thought it was perfect, making her look and feel sexy and older – at least seventeen. They went to the Spanish Steps where she confessed to being a fan of the Romantic poets, so they went next door to Shelley's house where Keats had died and where the smell of jasmine was intoxicating.

They strolled around in the Protestant cemetery and he pointed out the hundreds of cats at the nearby pyramid. They had lunch and discussed Keats' *Ode on a Grecian Urn*. Although he wasn't a fan, he liked how the poem described the ancient artwork while she argued for its message of eternal beauty and love. He made jokes about the British needing Italy to be poetic, but did seem to genuinely enjoy showing her their monuments.

The café was loud so they leaned in close across the table as they talked, maintaining continuous eye contact. She was thrilled because she knew this must make them look like lovers. By the end of the day she was imagining staying in Rome to live as his mistress. They would tour the country together making love on trains, in quiet gardens, under fig trees, and amongst jasmine vines. When in the city, they would spend entire days lingering over those precious piles of papers at his studio. He would read to her from Dante and they would do it on the leather chair with the windows opened wide and all of Rome at their command. She knew for the first time ever that she was in love.

Back at her hotel, he leaned down and gave her a goodbye kiss on the forehead. He lingered there a few seconds too long. In those few seconds her heart began to beat fast and loud. She desperately hoped that he would hear it. She longed to press her body against his, to declare her devotion to him, to wrap her legs around him, to fall to her knees begging him to keep her with him. . . .

Sadly, her memory slipped away and in its place was a loud unwelcome ringing. It was the telephone. Annoyed, she watched it ring several more times but did not answer. She was confused and cold from spending the entire night sleeping fully dressed on top of the bedcovers. She surveyed the strange room. In last night's distraught state, she had failed to notice how glorious the room was. She had left the curtains open and now sunlight was streaming in through the large glass patio doors. The king-sized bed was in the center of the room. The walls were decorated with distressed remains of frescos, the high ceiling was the

color of the sky and from it hung a large glass chandelier. The room was sparsely furnished but every piece looked to be hundreds of years old and in pristine condition. On the dresser was a large bouquet of gorgeous pink roses.

She got up and opened the patio doors and admired the garden below. The familiar scent of jasmine drifted in and mingled with the fragrant roses. She had really slept in; it was past noon and the opening was in a few hours. In a hurry, she ordered an espresso from room service and sent her dress downstairs to be pressed. She started the bath, took off her clothes, examined her body in the mirror, and was pleased by how she looked. The underwire in her bra had left what felt like permanent marks on her chest. Her breasts were considerably smaller than Rosa's but they were lovely and even bra-less they pointed upwards, which she knew Rosa's couldn't do. She gave them a gentle squeeze and her nipples stood up, making her smile.

She took her bath, shaved her legs, and applied fresh polish to her fingers and toes. She put her hair up. Her neatly pressed dress and her coffee had arrived while she was in the bath. She quickly drank her coffee which had now gone cold but luckily still packed the punch she needed to battle her jetlag. Her black dress clung to her body perfectly. It looked much nicer without underwear so she decided to be bold and go without! She blushed, imagining pulling up her dress and them doing it right there in the gallery in front of all the shocked art patrons – she laughed, perhaps, if she were a performance artist!

Genny admired her polished toes in her strappy gold sandals, then took one last look in the mirror and

then around the room to make sure everything was in order. In the bright sunlight, the outline of her nipples was faintly visible through the gauzy fabric. She doubted there would be such direct light in the gallery but was delighted by it nonetheless, thinking it might make a special greeting for him.

There was a loud knock at the door. It was Rosa. She had come to escort Genny to the opening. She barged in looking elegant and professional in a stylishly cut linen suit. Rosa seemed tense and in a big hurry. She was saying something about being worried and calling all morning and that they had to go and that she looked nice and that her aunt had been trying to reach her and who sent her such lovely roses?

Genny blushed, realizing she was still standing in the sun and that she was now unintentionally giving Rosa her special greeting. She reached for her shawl. She had assumed the flowers were from the gallery and for the first time she noticed that there was a little card with them. Her name was written on the envelope in familiar handwriting. Why hadn't she seen the card earlier? How did he even know where she was staying when she herself barely knew?

She wanted to tear it open but couldn't read it now. Instead she smiled calmly at Rosa, took the small envelope and put it in her gold clutch, and together they left the room. While Rosa went to get the car, Genny stopped at the hotel desk to get her messages. There were three from Rosa and one from Gina. She had slept through a lot of ringing. She glanced quickly at Rosa's and crumpled them into a ball. Gina's read, "Just got invite today. Why didn't you tell me? Too late now. Will miss opening. Good luck. Gina." Genny had

to hurry. Rosa would be back any minute. She slipped her hand into her purse and found his envelope but it was too late. She could hear Rosa honking at her from the Fiat.

During the short ride from the hotel to the gallery, it dawned on Genny that she must have been wrong about everything. Gina had not set up her exhibition. He had. Genny had such a warm feeling inside she felt that she must be glowing.

The gallery was very grand. It looked like a church with vaulted ceiling and marble floors, unlike anywhere she had ever exhibited before. She wandered off on her own to look for him, smiling politely at people she had no interest in meeting. She could see a small crowd gathering around her work. Never before had she felt such happiness. Then she finally saw him. He looked thinner and there was some gray in his hair, but he was even more handsome than she had remembered. She watched him smile when he saw Rosa, and much to her horror he greeted her with a kiss. She felt her blood begin to boil. Her suspicions were correct. They did in fact know each other very well.

Genny saw them looking around for her so she quickly ducked outside onto the terrace. She needed to think, to remind herself to breathe. Her heart was pounding, he was here and he was looking for her. What about Rosa? She would not allow Rosa to ruin everything. She tried to rationalize; Rosa must be someone he found for amusement, someone to pass the time with in her absence. She would wait until Rosa left his side and then she would make her move, sure that once he saw her he could no longer care for Rosa. He had after all been responsible for her trip

here. She remembered the card. She quickly found it and read it fast several times over and then once again more slowly.

She was such a fool! Her jealousy began to melt away leaving in its place the deepest sense of joy and satisfaction. Among the sweet and numerous protestations of his love and desire, he explained that he had been called to Turin on important family business, expressed sorrow at being unable to see her until the opening, and that he had asked his niece Rosa to help see to her comfort in his absence. She couldn't believe how wrong she had gotten things.

Scolding herself, she was resolved to conduct herself with reason rather than passion in the future. Slowly it was all beginning to make sense. With a smile she realized why she had been put in such a luxurious hotel room. He had done it all through the gallery and with Rosa's help. Once again, her confused feelings for Rosa underwent a final and drastic change. She now felt grateful to Rosa, who had made sure Genny knew who sent the flowers.

The sun was beginning to set but it still felt warm on her forehead. She took a breath and turned to go back inside but found she could not move her legs. He was standing directly in front of her. She felt the strong force of his gaze. They stood motionless and speechless. She studied his face. This face that she dreamed of was older now. It had more lines and she loved it more than ever. She longed to kiss him on the lips and feel his body against hers but she still could not move. His eyes silently spoke to her of his love as they eagerly examined her. She knew she had changed quite and a bit, but from his slow gentle smile she could tell he was not displeased.

She smiled back, unable to contain her joy. He stepped toward her and she trembled with excitement as she prepared herself for the electric shock of his touch. Suddenly she heard loud laughter and voices. Out of nowhere the exhibition curator appeared. How long were they standing there? What must it have looked like? With no hesitation the curator interrupted them. He had been looking for her and was happy to meet her in person after all of their telephone conversations. He brought with him a prominent collector who wanted to buy her drawings. This was devastating. She hadn't even heard his voice yet.

She wanted to tell the curator to go and that the work was not for sale. Her body ached for him. His face seemed to register her distress and although she could see his disappointment, he managed to give her a sweet smile. It reminded her of the day he offered her an espresso and it gave her the strength to go. Genny wasn't worried. She had read his card and knew to expect him back at the hotel. They had been so intimate from such a great distance and now they would be closer than she knew how to imagine, even though she had been dreaming about it for ten years. She would go now with this curator but she wasn't really leaving him. She would never leave him again.

A CASE OF INSECURITY

There is no such thing as security, there never has been, and yet we speak of security as something which people are entitled to; we explain neurosis and psychosis as springing from the lack of it. I explain this to myself as the bulky torso of the Peter Pan bus pushes its way north along the Hudson River parkway. I am the youngest chief investigator for Lloyds Wintertur insurance company and I am on my way to prison. I am the best in the business, I have been told but they also say that I am a bit insensitive. I get the job done! My name is Genny O.

I'm not really going to prison I'm going to *the* prison. Attica! The prison that was the scene of the great riots where the inmates took charge and Governor Rockefeller let them talk to the TV cameramen. I am going to Attica to investigate the robbery of a piece of fine art. That's my specialty, fine art claims, and this is a good case, a complicated one. It seems the guards have stolen a Salvador Dalí drawing that he donated to the prison, or more precisely the prison

inmates themselves, more than forty years ago. Now it's valued at $250,000 and they want my company to pay. My job is to find a catch, a way out, so that my insurance company doesn't have to pay. Genny O always finds a catch!

Probably the only place where a person can really feel secure anymore is in a maximum-security prison, except for the insecure possibility of imminent release. Security is when everything is settled, when nothing can happen to you. Security is the denial of life. It's every insurance man's dream. A prison should be, from my professional standpoint, the safest place to keep an artwork. That's why we gave them our cheapest policy and now they want us to pay up. Although security is not in the nature of things, we invent strategies for out-witting fortune and call them after their guiding deity insurance. We employ security services, pay security guards, and yet we know that the universe retains pow-ers of unforeseen disaster that cannot be indemnified. We know that money cannot repay a lost leg or a life-time of headaches or scarred beauty but we arrange it just the same. My name is Genny O and insurance is my game.

"Popcorn or party mix?" I am lost in thought. "Hey lady, popcorn or party mix?" I am awakened out of my deep existential questioning. Awakened by the real world. "Party mix, please," I say. It seems that Peter Pan bus lines is trying to feed its passen-gers a snack. Busses these days have a fantasy about being airplanes. But in the U.S. at least only poor people, or old people, or people who have lost their driver's licenses ride the bus. So where do I fit in? I'm not so poor. I'm definitely not old, in fact I look

twenty-five maximum, and I'm actually quite attractive except perhaps I'm a bit overweight. I'm a bit insecure about my weight, as you might guess. There is that word "insecure" again. Part of the mystery in our use of it is that somehow it implies blame. I blame myself for being insecure. There must be some loophole, some clause that I have forgotten. I mean about the Dalí drawing. Insurance protects the owners of property against theft but if the guards are thought of as the de facto owners of the prison, owners can't steal their own property. So the insurance policy must be void! No that can't be it. Think, Genny, think! There has got to be a way out.

Around me on the bus, everyone is talking on their cellphones even though Peter Pan policy is three minutes per trip and ringers must be set on vibrate. There is a guy behind me who's been talking on his for about an hour trying to convince a friend to come with him to Las Vegas for his bachelor party. The incitement is hookers and limos and the cash value of female charms. He is secure in his belief that as a lover he will be equal to the expectations of professionals. The logic of my profession; insurance, or assurance if you please, tells me that his expectations are an essential part of his conceptual apparatus. Such a dull pessimistic attitude. I believe that the ideal sexual partner should give promise of a good tussle. Pyrotechnics, explosives, wild animals, deep sea diving, all the fantasies of Las Vegas, and everyone has an insurance policy. The search for security is undertaken by the weakest part of the personality, by fear, inadequacy, fatigue, and anxiety. But my thoughts are interrupted again; the loud speaker on the bus

comes to life and it's the driver saying, "Please limit your cellphone usage." The guy behind me hangs up, as does the Chinese lady on my left, and finally there is silence. I decide to try and read.

I have brought a romance novel for the trip, entitled *Love Behind Bars*. It seemed appropriate for my journey, and anyway I might even get some ideas that will help me solve this case. Perhaps the Dalí drawing was stolen as a passionate gift by one guard for another. Or perhaps a guard stole it to win the affections of an inmate. The most significant operation of the romance myth is in the courting; the giving of gifts. Settings, clothes, precious objects all testify to the ritualization of sex, which is the essential character of romance. Flowers, little gifts, love letters, and poems are everywhere in prison, I'm told, where "little things mean a lot." Maybe two guards kissed for the first time near the Dalí drawing! It's become a souvenir of passion.

But that's stupid, Genny! Think! There must be some simple answer.

The man next to me at the window has to go to the bathroom, so I stand up in the aisle to let him pass. He is quite stylish, wearing a brown velour jumpsuit and covered from head to toe with fuzzy red hair. I think he likes me too because he averts his eyes from mine as he tries to squeeze past. But why didn't I notice him until this moment? He is a bit like an overgrown Irish setter which reminds me why I ride the bus instead of driving my own car. The truth is that I am afraid of having an accident, not a normal accident where two cars collide, but a lonelier one. the kind where I accidentally run over someone's beloved pet

and don't even know it. Haven't you ever had that feeling? When something goes bump under your car but you keep on going and don't look back? One of my colleagues at the insurance company once told me that I am the kind of person who could kill someone and not even know it. My greatest fear is that I am oblivious, unaware of the damage that I cause just by moving through the world. I feel more secure letting someone else drive.

My problem is that I keep mixing up the security of life and possessions with emotional security. The real essence of the word security lies somewhere between durability and mutability. The passing away of all that is durable. That is insecurity. I want the kind of security that enables me to consider insecurity as freedom. "Attica," the bus driver is yelling. "Attica!" and I realize it is time to get out. I collect my bags from the overhead rack and just at that moment the problem becomes clear. If Salvador Dalí gave the drawing to the prison inmates, then the insurance policy is invalid unless the insurance money is divided among them, which the prison staff will never allow. Genny you're a genius, I say to myself as I step off the bus into the path of a speeding semi-truck. My last thought before I am sliced in two by its front wheels is that if we could just recognize insecurity as freedom, the freedom not to be taken for granted, oblivious, we would not be perceptibly worse off for it.

Los Angeles resident **John Baldessari**, is one of the most influential artists in the United States. He has yet to make boring art or a weak martini.

★★★

Erin Cosgrove is an artist living in Los Angeles. Her ongoing project is the creation of seven romance novels from the point of view of seven different authors – all named Erin Cosgrove. The first book in the series, *The Baader-Meinhof Affair*, depicts the unlikely amour between a student studying sadistic serial killers and a Baader-Meinhof Gang aficionado.

★★★

Douglas Coupland is a novelist and visual artist who lives in Vancouver, Canada.

★★★

Actor, author, humanitarian, and professional heart-throb, **Fabio** has been featured on over two thousand romance novel covers (totaling one hundred million novels world-wide). This ambassador of Romance has been dubbed the, "Sexiest Man in the World" by *Cosmopolitan Magazine* and the "God of Romance" by *Romance Times*.

★★★

Former infant model sensation "Baby" **Michele Hierholzer** is now a major star of the very independent cinema.

★★★

Rita McBride is an artist living and working in Cologne and New York Her projects vary greatly from unorthodox books to very large sculptures. She is currently planning a sixty-meter tall carbon structure entitled *Mae West* to be erected in **2006** on the Effnerplatz in Munich.

Jennifer Nelson is Los Angeles artist who lives somewhere else altogether. Formerly a professional dancer, she continues her physical investigations by making urgent and absurd "social choreographies" through performance, film, and video. Although fascinated by the effects of gravity, momentum, habit, and thought on human movement, she prefers to be moved by love.

★★★

Cate Rimmer is a Vancouver-based curator and writer. She has developed numerous exhibitions at the Charles H. Scott Gallery, as the founding director of Artspeak Gallery, and as a freelance curator in Vancouver and elsewhere.

★★★

Joe Scanlan is an artist living in Wellfleet, Massachusetts.

★★★

Kimberly Sexton is a visual artist living and working in New York City. She finds time to write when not making sculpture, drawings, photographs, and love.

★★★

Kathy Slade is an artist and writer who lives and works in Vancouver. Her practice includes computerized machine embroidery, sculpture, and film. She has exhibited her work in Vancouver, Victoria, Montreal, and Hong Kong.

★★★

Michael Turner is the author of *Hard Core Logo*, *American Whiskey Bar*, and *The Pornographer's Poem*. He has collaborated on scripts with artists Stan Douglas and Bruce LaBruce. Recently he was commissioned to write a libretto for the Modern Baroque Opera's version of *Max & Moritz: A Juvenile History In Seven Tricks*.

Heartways is the first of four Ways books edited by Rita McBride and Erin Cosgrove, Matthew Licht, Glen Rubsamen, and David Gray. The Ways books – entitled *Heartways, Crimeways, Futureways,* and *Myways* – exploit and decipher genre writing with an entertaining and refreshing collective structure. The books include contributions from more than fifty artists, architects, writers, journalists, curators, and critics.